Learn to Draw

Animated Cartoons

IF IT MOVES...SHOOT IT!

JANET NUNN
WITH
GRAHAM GARSIDE

First published in 2001 by
HarperCollins*Publishers*
77-85 Fulham Palace Road
Hammersmith, London W6 8JB

The HarperCollins website address is:
www.**fire**and**water**.com

06 05 04 03
8 7 6 5 4 3 2

© HarperCollins*Publishers*, 2001

Produced by Kingfisher Design, London
Editor: Tessa Rose
Art Director: Pedro Prá-Lopez
Designer: Frances Prá-Lopez

Contributing artist: Graham Garside – *all Artist's Tip box characters; pages 4 top,
centre (imp), 5 top and below right, 9, 13 (character), 14–15, 18–19, 22 top, 27 bottom
centre and right, 29 top and centre, 52 bottom right (cat), 53 bottom, 54, 55 top and
bottom right, 56, 62–63*

A catalogue record for this book is available from the British Library

ISBN 0 00 413410 9

Printed by Midas Printing Ltd, Hong Kong

How to 'flip' the animation sequences at the bottom of the pages of this book
You will see that there are animation sequences at the bottom corners of the
pages in this book. To bring these sequences to life, 'flip' the right-hand pages
from front to back with your thumb and forefinger and the left-hand pages from
back to front.

CONTENTS

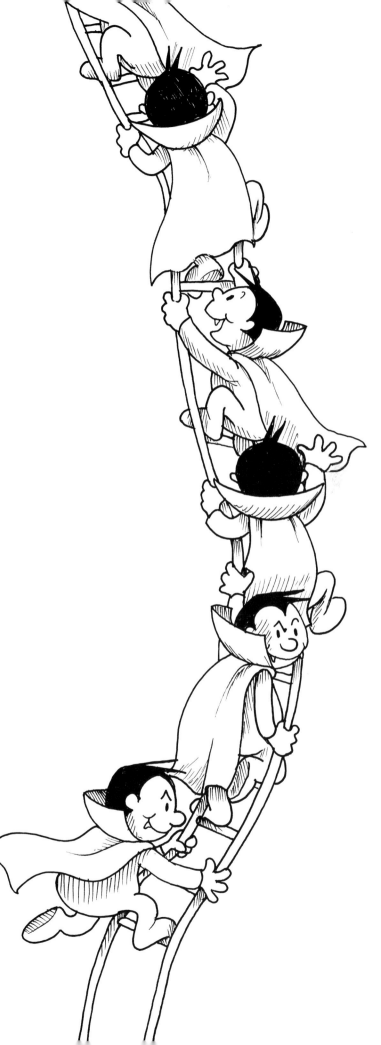

Introduction

If you have read *Learn to Draw Cartoons*, you might like to take your own drawings a few steps further – literally! Here you will find the first few simple techniques which will help you to give your characters a life of their own, and bring an extra dimension to your work.

A lively drawing can impart a real sense of suspended animation. Each one of us has fond memories of our first picture books, and in those books such illustrations captured our imaginations and we turned to them time and again. Whether they filled us with excitement, or made a chill run down our spine, there is no doubt that we will carry them with us subconsciously for the rest of our lives. From the exquisite draughtsmanship of John Tenniel's 'Alice' drawings, to the sensitive sketches of Ernest Shepard's 'Winnie-the-Pooh', artists have brought life, fun and an extra dimension to story-telling. It is no coincidence that Disney Studios feature a story-book opening in the title sequence of many of their cartoon films.

Today, when we consider movement in drawing, we naturally think of animated cartoons. Over the last fifty years and more they have become part of our culture and are as much a part of our childhood memories as the picture book was for our grandparents.

Learn to Draw Animated Cartoons aims to provide the 'missing link' between the lively drawing and the 'living' one. Not everyone wants to get involved in the technology of animation and there is no doubt that an aspiring animator has to make a considerable financial outlay in order to 'tool up' his studio, particularly if he decides to invest in scanners and other expensive toys!

In writing this book, I have called upon the support and the considerable graphic input of Graham Garside, an animator whose experience complements my own, and have shamelessly used him as a 'sounding board' throughout. Between us we have over fifty years' experience of working in animation studios, and we reckon that it is possible to enjoy making things move for yourself, without breaking the bank. In this book we plan to start by trying to improve our 'static' drawings and then see how our new-found skills can be used to produce small animated sequences which can either be produced in book form, or perhaps, for the more ambitious, translated onto computer disc.

The art of animation is very complex, but as with many other skills it is built upon experience and practice, and learning quite simple procedures one at a time. Although we cannot deal with the whole process of animation here, we can make a start on it … and the nice thing about it is that *anyone can make a drawing move!* You don't have to be a whizz-kid, you don't even have to be a particularly good draughtsman, but if you are really interested and want to do it, you can!

Tools and Equipment

You don't need to buy a lot of sophisticated equipment at the outset. You can begin with a small sketchpad, an old loose-leaf ring-binder, or even some sheets of paper held together by paper-clips. On this page you'll find the simple materials and pieces of equipment you'll need to get started. If later you find that you enjoy drawing animation, and would like to experiment further, you may be interested to know what kind of equipment is used by professional animators. You'll find a selection of these on pages 8–9.

PENCILS

It is important to feel comfortable with the materials you use. No-one wants to waste time with scratchy pencils or brittle leads, so take time to find a good range of pencils.

Blue pencil You will find that a soft blue 'roughing out' pencil will help you to get a feeling of movement as you draw. Your local art-shop will probably stock special designers' non-reprographic blue pencils. These are fine, but you can also use an ordinary pale blue pencil-crayon.

Black pencil When you have finished roughing out your work, you will need a sharp black pencil to 'clean it up'. Leads vary quite dramatically, but an HB is a favourite. If the HBs you try seem too hard, try a B in the same range. There are black lead pencils designed for animation, but these are not strictly necessary.

Propelling pencil A propelling pencil does not need sharpening, and produces the kind of clean, even line required for computerized animation. The drawbacks are that it is a rather 'clinical' instrument, and the leads are not robust. That said, it is worth mastering the technique of using this type of pencil. Find one which takes a size 0.5 lead, and try either HB or B grades.

PAPER

Remember that the paper you use should not be opaque, because you will need to work on several layers of drawings at a time. A layout pad, obtained from any good artists' suppliers, is ideal for your purpose. Start at the back of it, and work forward, laying one drawing over another and improving on them as you go.

Animation paper This is more opaque than layout paper, and rather stronger, because it gets more

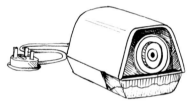

handling and needs to withstand extra wear and tear. It is designed for use on a light-box (see page 9). The most widely used size is called '12 field', which measures approximately 266 x 330mm.

Tracing paper is not suitable for animation, because it is too transparent and also damages easily.

OTHER ITEMS

Masking tape (*above*) This is used for taping down your paper or peg-bar, and is easily removed from both.

Pencil sharpener (*above*) If you do a lot of drawing, think about investing in an electric sharpener – you won't regret it.

Eraser (*below*) You should have one, but keep it a little out of reach, so that you only use it when you really need to. You would be surprised how seldom an eraser is used in an animation studio.

Mirror (*right*) It's not unusual to see an animator making fearsome faces at himself in a mirror placed alongside his desk. It is particularly useful when you want to make characters 'speak', and can be a great aid in helping you to capture elusive expressions or movements.

Ruler (*above*) Preferably choose a good metal one. In our experience wooden and plastic rulers usually end up looking rather 'chewed' and the gradations can become difficult to read.

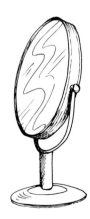

Your work station

Once you've assembled your tools, you'll need somewhere to work. Find yourself a quiet corner – away from the normal household 'traffic' – that is large enough for you to set up a firm, stable work top on which you can place a drawing board. You can buy these or construct one yourself. Any smooth, firm surface that can be angled to suit your requirements will do. A good desk-lamp is also vital: the adjustable clip-on types are excellent, cheap, and easily available. A chair which supports your back is essential too. Many hours spent stooping over your work can cause 'animator's hump'!

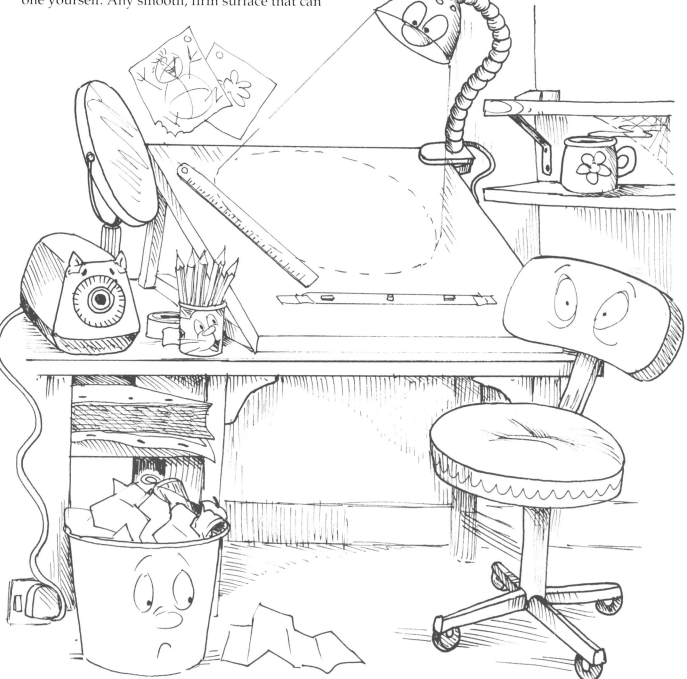

Registration systems

In order for a sequence of drawings to create the illusion of movement, they all have to be viewed in a fixed spatial relationship to one another. For this reason they need to be secured together and held physically in place, either by clips or a binding, or a special animation peg-bar.

peg-bar

We have already emphasized that you don't have to go to great expense equipping yourself for making your own animations, and it should be possible, with a little ingenuity, to rig up a perfectly acceptable registration system by cannibalizing an old loose-leaf ring-binder, and using punched paper from a pad. If you remove the metal spine holding the rings from the binder, and tape it down firmly, it will do the job quite well. Take care when you are working not to tear or distort the punched holes in your paper, or your drawings will soon slip out of register. Peg-hole reinforcing patches are to be found in any good stationery shop, and are a worthwhile buy.

You may feel that you would prefer to use a purpose-made peg-bar; any good stockist of art materials should be able to sell you a lightweight plastic peg-bar, or order one on your behalf. From the same source you will get boxes of ready-punched animation paper, and paper reinforcements for animation pegs. The good news is that the peg-bar will be fairly

inexpensive; the bad news is that the paper and peg-reinforcements will not! All these animation products meet the professional 'ACME' specifications, which were developed long ago in the United States. The 'ACME' standard peg-bar system is now used throughout the world, from Hollywood to Shanghai. Hence Bugs Bunny's frequent 'Acme' jokes

Animation disc

Professional animators work on a revolving glass or perspex disc, set into a slope, over a light-box. This disc can be swivelled easily, in order to bring the various parts of the drawing nearer to the artist as he works. The registration peg-bar is either taped to, or slotted into, the disc. The best of these 'set-ups' (see Jargon Buster, page 11) include a pair of sliding peg-bars at the top and bottom of the disc, which enable the animator to rehearse his camera-moves and move his drawings to right or left as necessary. Although this precision equipment is indispensable to a fully fledged animator, it is not cheap. Nor, you will be pleased to learn, is it absolutely necessary. Instead, you can simply tape your plastic peg-bar to a light-box. Then you'll be all ready to go!

animation disc

8

Light-box

If you're particularly bold and resourceful, or you want to save the expense of buying ready-made, you can make your own light-box. You will need the following:

• 50 x 100 cm (20 x 40 in) sheet of MDF (medium density fibreboard) or plywood, 15 mm thick, for the wooden frame; available from a DIY store.

• 30 cm (12 in) cold neon striplight, with fitting, wire flex, switch and plug; obtainable from any good electrical or lighting shop.

• Sheet of 6 mm (¼ in) thick opaline perspex, cut to size; a glass supplier should offer this service, and be able to cut extra thumbholes for the disc.

• Wood-glue, tacks and screws for assembly.

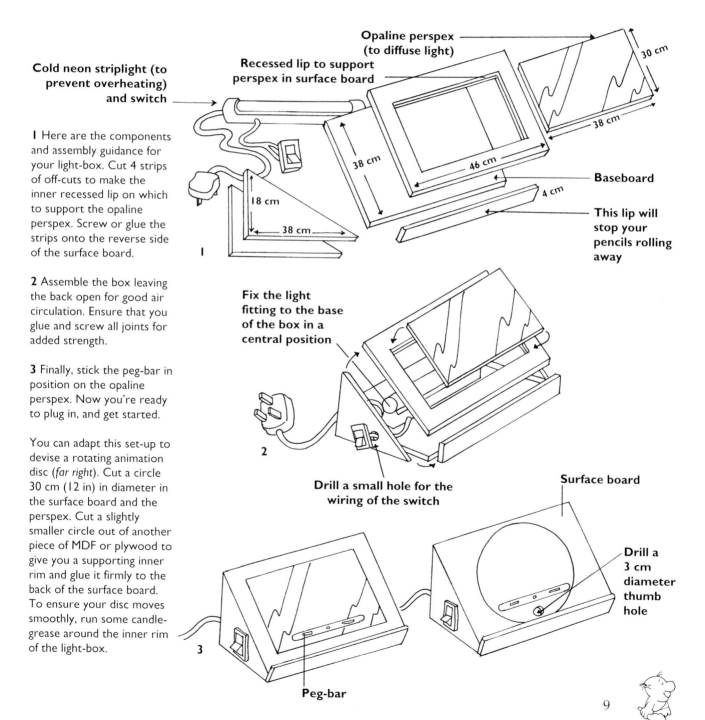

Cold neon striplight (to prevent overheating) and switch

1 Here are the components and assembly guidance for your light-box. Cut 4 strips of off-cuts to make the inner recessed lip on which to support the opaline perspex. Screw or glue the strips onto the reverse side of the surface board.

2 Assemble the box leaving the back open for good air circulation. Ensure that you glue and screw all joints for added strength.

3 Finally, stick the peg-bar in position on the opaline perspex. Now you're ready to plug in, and get started.

You can adapt this set-up to devise a rotating animation disc (*far right*). Cut a circle 30 cm (12 in) in diameter in the surface board and the perspex. Cut a slightly smaller circle out of another piece of MDF or plywood to give you a supporting inner rim and glue it firmly to the back of the surface board. To ensure your disc moves smoothly, run some candle-grease around the inner rim of the light-box.

Opaline perspex (to diffuse light)

Recessed lip to support perspex in surface board

30 cm

38 cm

38 cm

46 cm

18 cm

38 cm

4 cm

Baseboard

This lip will stop your pencils rolling away

Fix the light fitting to the base of the box in a central position

Drill a small hole for the wiring of the switch

Surface board

Drill a 3 cm diameter thumb hole

Peg-bar

Jargon Buster

Animation has an arcane language all of its own. Here are a few expressions that are commonly used by professional animators. With the advent of the computer some of these will soon be obsolete, but we have no doubt that more will soon evolve to take their place.

ACME
The world-wide standard animation registration system (see page 8).

ANTIC
Abbreviation of 'anticipation'. A drawing which precedes and accents an extreme movement.

BG
Background, against which the action takes place.

CAM
The camera; a few years ago this would have been a rostrum camera, mounted vertically above the artwork, but today it is more likely to be a computer system.

CC
A colour card, often used instead of a BG for close-ups.

CELS
Celluloids; now mostly things of the past, these are transparent sheets on which animation drawings were traced and painted.

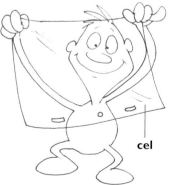

cel

CU (also **BCU**, **ECU**, and **MCU**)
Close-up shot; also Big Close-up, Extreme Close-up, and Mid Close-up.

CU

BCU

ECU

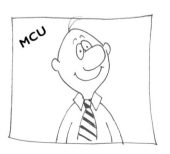

MCU

CYCLE
A sequence of drawings which can be repeated endlessly to give the impression of continuous movement, such as walking or running.

DOPE-SHEETS
The vital link between the animator and the camera/computer operator. The chart on which the numbered drawings are tabulated, showing where, and for how many frames, each one should be exposed.

dope-sheets

DRGS
Abbreviation for 'drawings'.

FIELD KEYS
The areas within which the action takes place (see Layout and Graticule).

FLIP
There are two meanings to this one: either the flipping of the drawings by the animator, to check the action, or the reversal of the drawings under camera, to show the action going in an opposite direction. (Also see Artist's Tip on page 31.)

CYCLE

FRAME
An isolated segment of film. Animators work to a discipline of 24 frames per second of film.

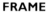

frames

FX
Special effects, such as water, fire, rain or snow.

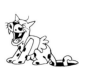

GRATICULE

A grid which corresponds to the camera's field of vision. Usually this is produced in two sizes: 15 Field, or the commoner 12 Field. Within this grid the layout artist can plan the action and any camera moves required.

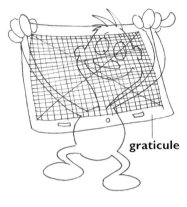

graticule

IN-BETWEENS

The 'filling-in' drawings which are created between 'key' drawings and help to smooth out – and slow down – the action where necessary.

KEYS

The important main position drawings which form the bare bones of any action.

LAYOUT

A set of staging drawings which tell the animator the action in any given 'scene'. An animation 'scene' is often less than five seconds long in real time, so the planning has to be precise.

LIP-SYNC

A set of drawings of mouth movements which are synchronized with the soundtrack to give the appearance of speech.

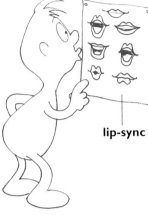

lip-sync

MIX

One picture fades out as the next fades in, so that the change of scene is almost imperceptible.

MORPHING

Gradually changing the form of a character by a series of drawings.

PAN

The lateral movement of a character or a background to right or left (as in walking, when a character walks 'on the spot', as the background pans from east to west behind it, giving the impression of forward movement).

PANNERS

This term usually refers to the extended backgrounds needed to perform the panning operation (see Pan above), but it also refers to the extra long peg-bars on which they are mounted.

PEG-BARS (also PEGS)

The flat bars, with centrally placed round posts flanked by oblong blocks, which hold drawings (done on specially punched paper) in perfect register under the camera. (See 'Acme' system and page 8.)

REGISTRATION

The organization of animation drawings under camera (see page 8).

ROUGHS

The first rough drawings planning the keys and in-betweens (see above).

SET-UP

Again this term has two meanings: it refers either to all the elements of a piece of animation ready to shoot, complete with background, as often used for publicity 'stills', or simply to the animator's work-desk, complete with animation disc, peg-bars and light-box.

SPLAT

The special effects that emphasize an object falling from a great height, or hitting another object at speed, usually accompanied by an appropriately descriptive sound-effect!

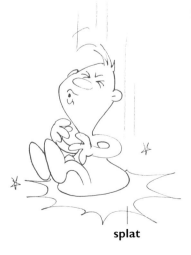

splat

SQUASH

The drawing which comes before a 'stretch'; see 'antic'.

STORYBOARD

A visual comic-strip style breakdown of all the action in a film. The jumping-off point for the whole production. On a major project, the storyboard artist visualizes the action, in consultation with the director, the script-writer and the key animators.

STRETCH

Essentially a stretched key drawing, which comes after and contrasts with a 'squashed' drawing, and gives more of a punch to the movement portrayed.

THANX

How most polite inter-studio notes end!

TRACK

Either the soundtrack of the film or a move in which the camera focuses on a different part of the main set-up. It can move further away from the subject (tracking out) or closer to it (tracking in). The speed of the move can vary, too, between a 'fast-track' and a 'slow-track'.

ZOOM

An extra-fast camera move, either panning or tracking.

Getting Started

Loosen up

Even if you didn't get to first base in art-class, there's no reason why you can't enjoy making your first attempts at drawing movement. All you have to do is relax. You may have to practise this. The idea is not to become so limp that the pencil falls from your nerveless fingers. You need to be comfortably relaxed, so that you feel at ease as you are working. Animation is really acting, drawn on paper. If you are tense, you are going to have the equivalent of stage-fright and make rigid little drawings. So, please, relax – this applies even if you got straight As in art!

Making your mark

Don't just stare at that empty piece of paper – take a blue pencil and make your first mark. This is your loosening up exercise. You don't have to impress anyone else with it. This is just for you. Start by drawing the shapes you tend to 'doodle' most, which come easily to you – fast!

You are aiming to make fast, scribbly sketches. Look around the room, and scribble down any objects you see. If you can persuade the family pet to walk past and give you a profile, so much the better, scribble that down too.

When sketching don't worry about technique or accuracy, just try to capture what you see instantly. Once you feel more confident, pop a pencil and a small sketchbook in your pocket and try sketching outdoors.

12

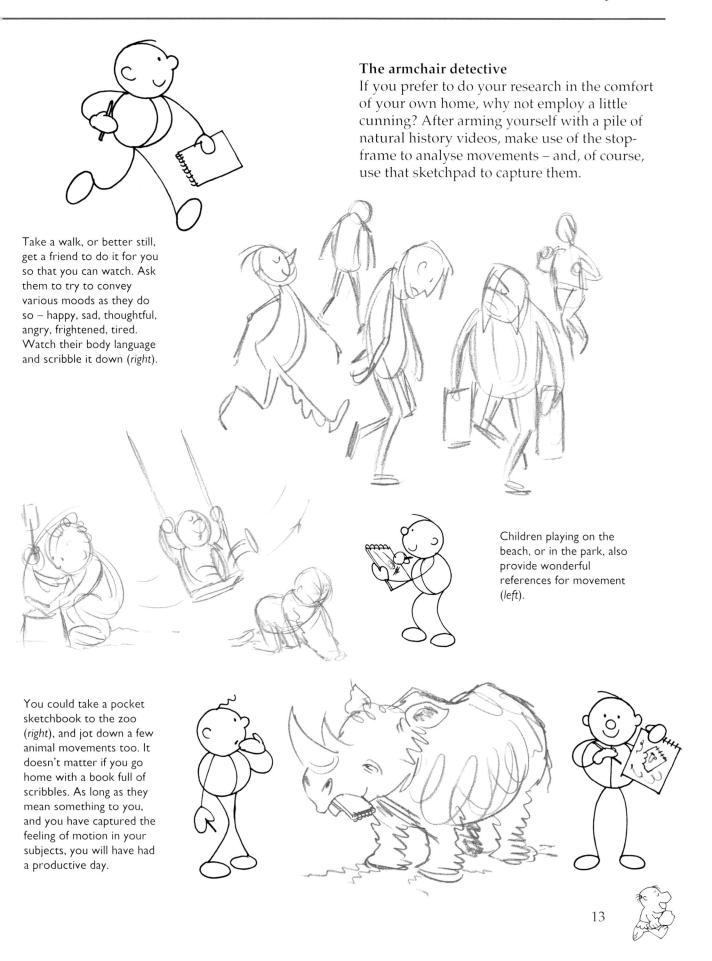

The armchair detective

If you prefer to do your research in the comfort of your own home, why not employ a little cunning? After arming yourself with a pile of natural history videos, make use of the stop-frame to analyse movements – and, of course, use that sketchpad to capture them.

Take a walk, or better still, get a friend to do it for you so that you can watch. Ask them to try to convey various moods as they do so – happy, sad, thoughtful, angry, frightened, tired. Watch their body language and scribble it down (*right*).

Children playing on the beach, or in the park, also provide wonderful references for movement (*left*).

You could take a pocket sketchbook to the zoo (*right*), and jot down a few animal movements too. It doesn't matter if you go home with a book full of scribbles. As long as they mean something to you, and you have captured the feeling of motion in your subjects, you will have had a productive day.

Give it Body

Every drama needs a hero. The beauty of animation is that you don't have to audition hundreds of actors for the Mr Right for the drama you are creating. You can simply invent your own. Your animated hero is incredibly versatile too, able to suffer all kinds of indignities – from squashing to slicing and dicing – and still come up smiling in a way that a James Bond, for example, never can, no matter how sophisticated his hi-tech toys.

In the series of drawings shown on this page, you can see how easy it can be to evolve a character. Everyone can draw a rough square, so let's just start moving along from there.

It is common practice these days to call drawn animation '2D animation'. There is nothing two-dimensional about it at all, as the following series of drawings shows – an animator always thinks 'in the round'.

Here is a flat square; think of it as an empty bean-bag.

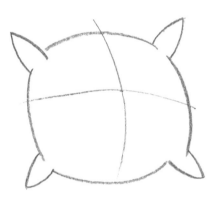

When you start to fill it, you are giving it body ...

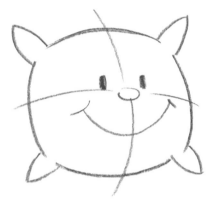

Give it a face, and it starts to take on a character all of its own.

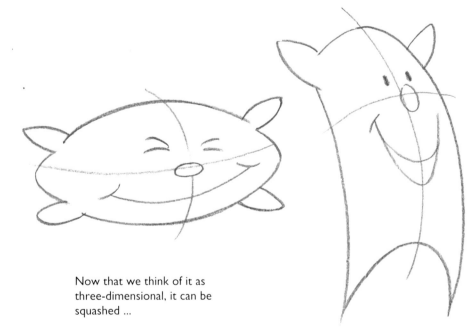

Now that we think of it as three-dimensional, it can be squashed ...

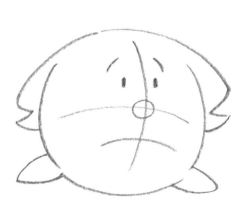

... and begin to develop a personality.

... and stretched ...

Body language

Look at the series of images below and notice how the bean-bag character is already beginning to develop its own body language, and adopting different poses to express itself. The corners of the 'bean-bag', for example, can become ears, arms, feet or legs and help to accentuate the mood or personality type.

As you draw always try to keep the volume of the character mass consistent. Imagine that your 'bean-bag' has alternative 'fillings', such as air or water. Consider the effect of weightlessness, then think about where the weight would settle in a heavy soft container. Start thinking about this now, and it will help you to give your drawings more impact.

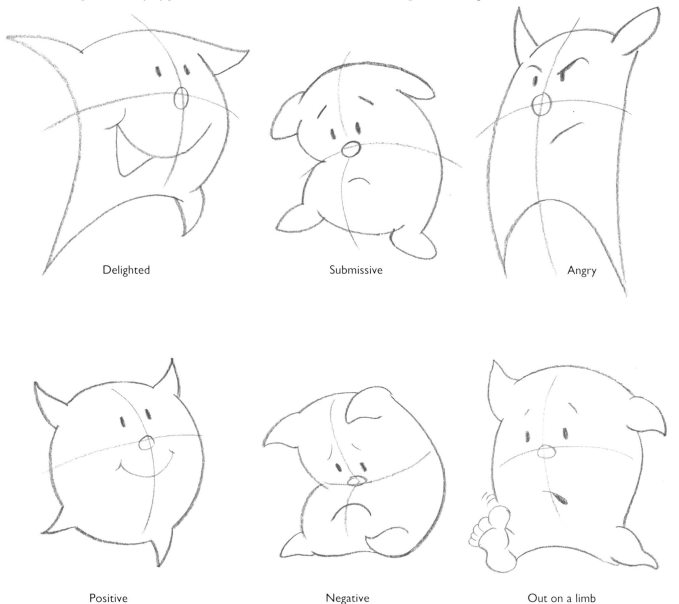

Delighted

Submissive

Angry

Positive

Negative

Out on a limb

Give it Weight

One of the first things we must do when we are drawing movement is to think about the weight of the character or object we are portraying. Naturally, creatures and objects have varying weights as well as sizes. We can, of course, make a visual joke and turn the whole question of weight upside down, by, for example, making an elephant float on air, or bringing a sparrow in to land on the roof of a bus and flattening it. But we can't play either of these little tricks until we have considered the way to deal with weight.

The bouncing ball principle

Below is a simple illustrated explanation of why an awareness of weight is so important to movement. It's called the bouncing ball routine and it's one which you can experiment with to your heart's content. Start by putting a piece of paper on your peg-bar, draw a couple of arcs and a ground-line on it and then, following this guide, start bouncing!

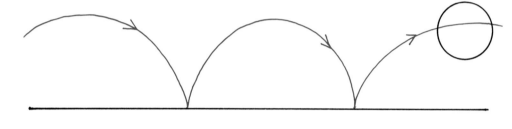

We all know that a bouncing ball will follow a set pattern as it travels and will progress in a series of arcs. We also know that at the end of each arc it hits the ground and then bounces up again (*top right*).

But if we simply draw the movement like this and forget about the weight of the ball, we will just show a mechanical progression and lose the vitality of the movement (*middle right*).

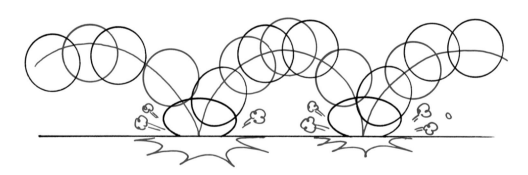

As the ball hits the ground, its weight causes an impact. In animated drawings we show this impact by exaggerating it, for example by showing the ball squashed and distorted as it lands. To really emphasize what is happening and also to remind the viewer that there's a hefty thump at this point, we also draw a 'splat' mark. This is a familiar device that we've all seen in action comics. When it is used in animated films, though, it actually moves (*bottom right*).

The force of the impact lifts the ball off the ground again, sending it soaring into the air. At this point we draw a ball which is stretched and streamlined, to emphasize the idea that it is flying. As it flies up we slow the movement, by putting in extra drawings. This gives the impression that the ball is virtually floating on air.

By the time the ball reaches the top of the arc, it has resumed its normal shape again. At this point, responding to the pull of gravity, it comes down to earth faster than it went up, and impacts again.

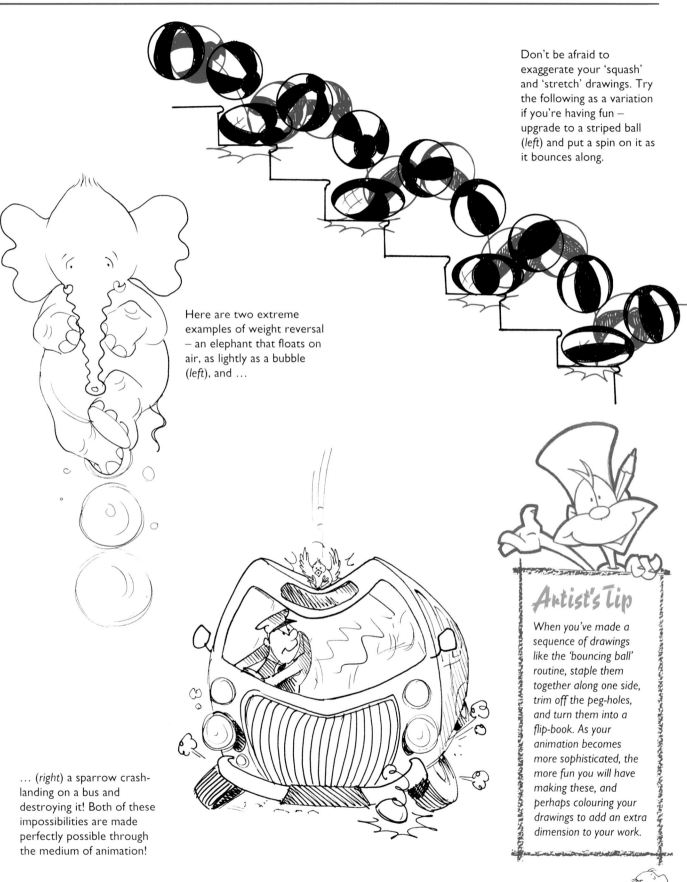

Don't be afraid to exaggerate your 'squash' and 'stretch' drawings. Try the following as a variation if you're having fun – upgrade to a striped ball (*left*) and put a spin on it as it bounces along.

Here are two extreme examples of weight reversal – an elephant that floats on air, as lightly as a bubble (*left*), and …

… (*right*) a sparrow crash-landing on a bus and destroying it! Both of these impossibilities are made perfectly possible through the medium of animation!

Artist's Tip

When you've made a sequence of drawings like the 'bouncing ball' routine, staple them together along one side, trim off the peg-holes, and turn them into a flip-book. As your animation becomes more sophisticated, the more fun you will have making these, and perhaps colouring your drawings to add an extra dimension to your work.

Check Your Speed

Some time ago, gravity introduced itself to the world by hitting Sir Isaac Newton on the head with an apple. History does not tell us which of them got the bigger bruising, but we do know that gravity continues to exert its pull to this day. Although we can bend the rules in animation, and let a character walk off a cliff and continue to plod along cheerfully in mid-air, sooner or later he will realize the error of his ways, look panic-stricken at the camera, and come down to earth with a bump!

Let us consider, then, the case of the anvil and the feather. To demonstrate the properties of these particular items, we have enlisted the services of two of animation's classic protagonists, the cat and the mouse. The mouse has drawn the short straw this time, as you will see from the sequence below, and is on the receiving end. Fans of the famous animation duo Tom and Jerry will know that this is not an unusual scenario in a cat-and-mouse movie, although the outcome is often unpredictable.

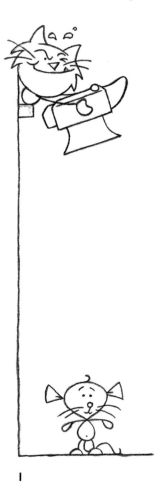

1

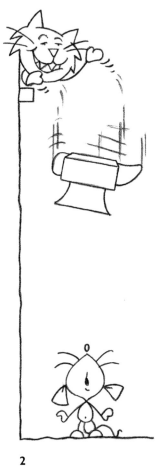

2

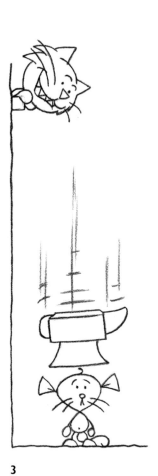

3

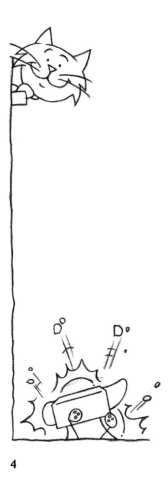

4

1 Our tomcat is poised to drop the anvil from a considerable height directly on to the head of the unsuspecting mouse.

2–3 You will notice that the anvil falls very fast and straight, indicating considerable weight. The speed of the move means you will need to make very few drawings.

4 The thud of the anvil hitting the ground can be emphasized by the use of a 'splat' and a cloud of dust. The 'splat' can be likened to a dry splash, which usually consists of three or

four drawings radiating out from the point of impact. It is a well-loved comic-book convention, often used in animation to add emphasis and a visual exclamation mark to the action.

Special speed effects

In addition to adding exclamation marks to any action in the form of 'splats', an animator can also call for a camera-shake. This is the familiar earthquake-like shudder when the whole picture vibrates. If done in combination with appropriate sound effects, it leaves nothing to the imagination. For the anvil sequence shown opposite, you would expect to see a vertical camera-shake. For a character running headlong into a wall the shake would be from side to side.

After downing a headache pill and a glass of water, our mouse has declared himself ready to take part in our next experiment (see below).

Reassurance for animal lovers: no animals were injured during the drawing of either sequence.

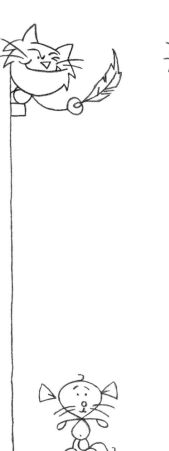

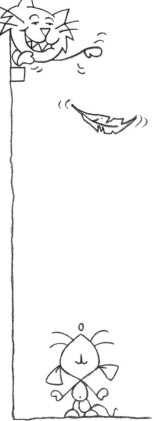

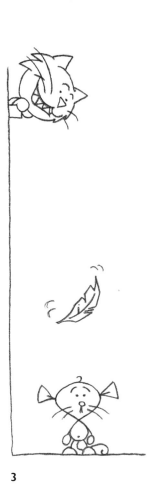

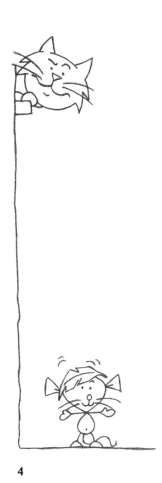

1

2

3

4

1 The feather is about to be released on its slow journey earthwards. Who knows where it may land?

2 Because of its light weight the feather responds to the faintest side wind and follows a wavy trajectory.

3 The movement is so slow that you will need many more drawings to show the feather's progress than you did for the fall of the anvil in the first sequence.

4 At last the feather comes to rest, gently, with no distortion. And there you have it – a happy ending.

Developing a Human Character

When it comes to developing a 'human' character, there are lots of permutations to consider. The most obvious of these concern what the character looks like: tall or short, fat or thin? The possibilities are endless, but, for the purposes of this first exercise in character design, let us choose three basic body-types: 'short and fat', 'normal' and 'tall and thin'.

We'll keep these characters cartoony, and base them on a simple 'bean' shape, which can be easily squashed or stretched. This is not the only way to build up a character by any means, but using an organic form as opposed to a geometric one may help your first attempts. The idea is always to keep your shapes loose and supple and avoid stiffness.

Even our earliest 'pin-men' drawings reflect our observation of body-types.

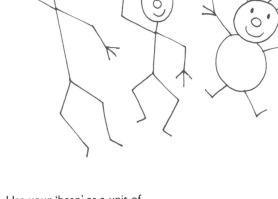

Start by tracing five 'beans' in a vertical line on a large sheet of paper (below). Together these beans denote the size of a tall, thin character. The first 'bean' represents the size of the head.

Beside it, repeat the process, this time using four beans. This will give you the rough proportions of a 'normal' body-type.

Lastly, tracing three beans onto the paper will give you the size of a short, fat character.

Use your 'bean' as a unit of measurement (below). Put a sheet of paper on your peg-bar, then draw your bean-shape on a small separate piece of paper, and slide it underneath.

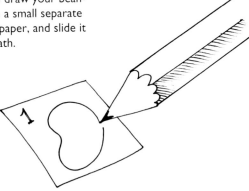

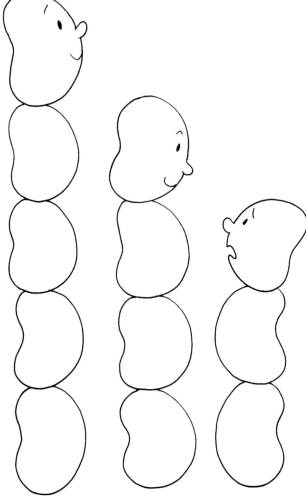

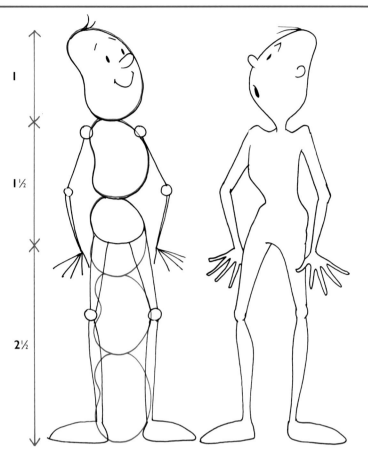

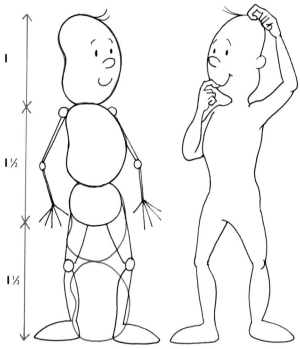

Take your five-bean column, and, counting downwards, allow one bean for the head (go on, give it a face, so that it can see what's happening!) and one and a half beans for the torso. The rest of the height belongs to a pair of long spindly legs. Now give it a pair of long spindly arms to match (*above*).

Now you can trim off any excess weight, and maybe add a skinny neck and some bony shoulders, just to accentuate the particular build of your character and complete the picture (*above*).

Next, tackle the 'normal' character (*above*). Again, allow one and a half beans for the body, but this time you will see that the legs will be shorter. When you clean up the drawing, do not add too much weight to the limbs and body.

The three-bean character has only a one-bean size body. If you add a bit of roundness to it when you clean up the drawing, you will notice that it looks quite cherubic (*right*). These are the proportions which are generally used when drawing cartoon children.

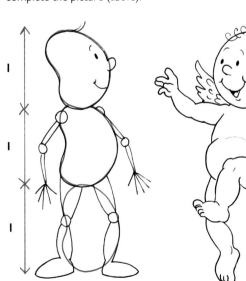

Artist's Tip

Once you have decided on the proportions of your character (the size of its feet, head and hands, and length of its limbs in relation to its body), you have made a set of rules which you must obey. If you don't keep to these guidelines when redrawing, you will gradually 'lose' the character altogether.

Developing Animal Characters

The fantasy zoo

You don't have to limit your drawing to the movement of bipeds. Remember, there is a whole natural world out there, padding around on four feet. In addition, there is also an unnatural world full of monsters and spooks, so you can utilize the stuff that dreams (or nightmares) are made of, too, and create creatures of your own. While pigs might fly, horses, bears and lions all walk in different ways, dependent on factors such as weight distribution and the structure of their feet. The permutations are seemingly limitless, and if you want to discover more a good series of wildlife videos should give you ample scope to study four-footed animals in motion, and will be a lot less hazardous than taking a walk with a polar bear!

Graham Garside's design, based on a North American Indian totem pole (*right*), incorporates five stylized characters standing on each other's heads. The chunkiness of these particular forms reminds us that they are animated woodcarvings. You may find it easier to build animal characters using rounder, more organic shapes.

Once again, a simple formula should produce a range of characters of different shapes and sizes (*right and below*). This time, it couldn't be easier. A small egg, a large egg and a leg at each corner. Now all you have to do is juggle the size ratios of the components.

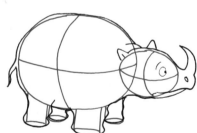

A medium-sized body with a small head and a long neck (*right*) sets the pattern for the camel, the llama or, with a bit of a stretch, the giraffe. The same body with a shorter neck gives the framework for a horse or cow. Whether you give your creature a neck or no neck makes all the difference between an elephant and a giraffe.

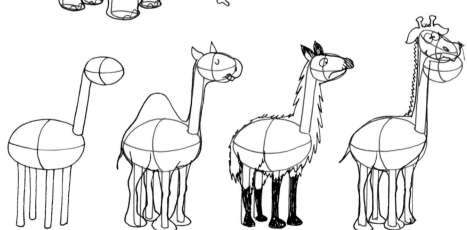

If you are intent upon portraying an animal for your animation sequence, you will need to use photographs or videos as reference to get an idea of its features as well as its movement. Even cartoon animals benefit from an eye to detail, so it is important to get them right. You may decide to emphasize one particular feature, such as a camel's flat feet, or a horse's big teeth, or you may invent a creature which combines the parts of several different animals. Mother Nature seems to have done just that on occasion – think of the duck-billed platypus.

By altering the ears, snout and tail and adding naturalistic shaping to the legs, you can change a wild African animal into a domestic pet or a rodent (*right and below*).

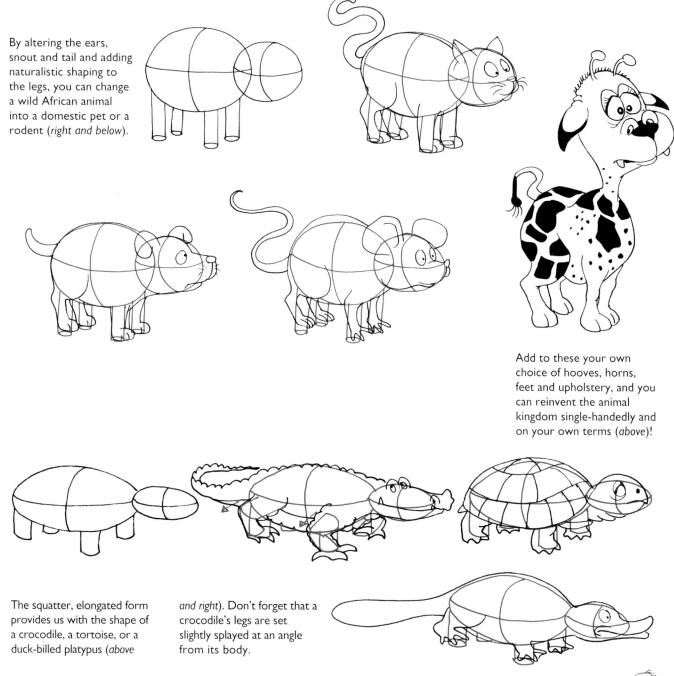

Add to these your own choice of hooves, horns, feet and upholstery, and you can reinvent the animal kingdom single-handedly and on your own terms (*above*)!

The squatter, elongated form provides us with the shape of a crocodile, a tortoise, or a duck-billed platypus (*above and right*). Don't forget that a crocodile's legs are set slightly splayed at an angle from its body.

Basic Proportions of Head and Face

Human and animal

There is no 'right' way to draw a face. The standard issue is two ears, two eyes, a nose and a mouth, and it is their size and relationship to one another which gives the face its character. Let's assume that the proportions given below are the norm, remembering that 'imperfections' can produce beauty as well as ugliness.

It is easy for us to recognize human attributes in animals. Most of us know at least one zoo inmate who bears a striking resemblance to somebody we know, and vice versa. In some famous cartoon characters the human and animal characteristics sometimes combine so well that we forget the creature's origin. Goofy is a prime example of this.

Draw an oval shape on a piece of paper, and divide it down the middle (*right*). Now draw a line across the oval, about two thirds of the way up. The point where these two lines intersect will give you the position of the bridge of the nose. The eyebrows will sit along the horizontal line on either side of this. Divide the face area with another line about halfway between the brow-line and the 'chin', and this will give you the position of the base of the nose. The mouth will rest on a line drawn about two-thirds of the way between this and the chin. On the side of the head, the ears are placed at about the same level as the nose.

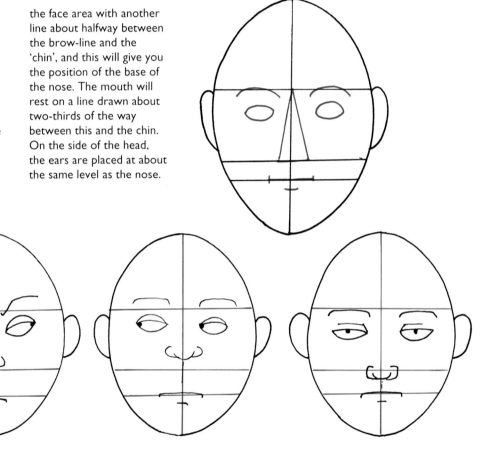

Using the framework of these facial proportions, you can build up a wide range of different facial types (*above*). Think of all the important accessories – eyes, noses, mouths, not forgetting eyebrows, hairstyles and teeth. If you ever played a game called 'Mr Potato Head' as a child, this is a super version of it.

We can recognize as 'faces' features drawn on inanimate objects (*left*). It is surprising to note that even quite widely spaced and minimal features still register with us in this way.

Animals tend to have their facial features set very close together, on a wedge-shaped head (*right*). The elongation, or telescoping, of the snout can produce different aspects of the same basic character, though.

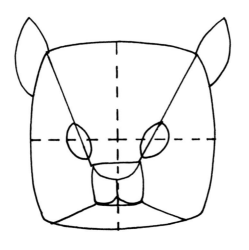

As with the human face, the exaggeration of the brows and eyes (*below*) can give a range of different expressions, from eager and happy through anxious to menace.

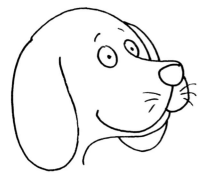

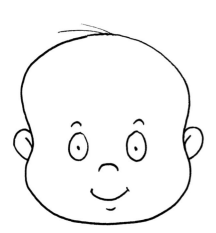

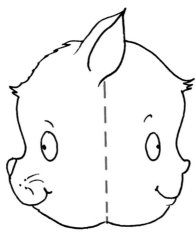

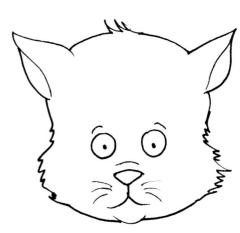

This cute character has the proportions of a baby's head. The face only occupies half the front of the skull. The large eyes give the character an

instant appeal. We see this formula used time and again in the portrayal of kittens and puppies, but it has also produced those old-timers Elmer Fudd and Mr Magoo.

Now, you try a few facial experiments. Draw a basic head shape on a piece of paper, then, laying another sheet on top, create the good, the bad, and the ugly.

Expression and Emotion

How are you feeling?

Once you have understood the 'geography' of the face, you can begin to experiment with its choreography, too. The eyes and nose may be static, but you can make the other features work to express emotions without words.

Give your first 'face' (*left*) a button nose, basic round eyes, and lines for the mouth and eyebrows. This face will have a perfectly bland expression.

Now (*right*), by changing a line here or there, we can give the same face a whole range of expressions.

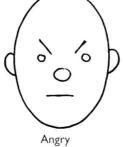 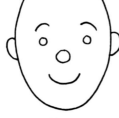 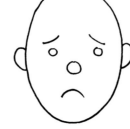 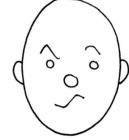

Angry	Happy	Sad	Suspicious

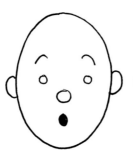 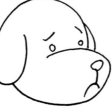 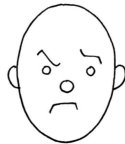 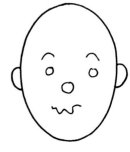

Surprised	Startled	Grumpy	Queasy

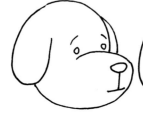 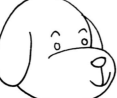 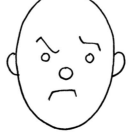

The same basic rules apply if you want more complex faces. When you are developing a character, it is always a good idea to do a sheet of expressions to show how that character will look in a range of different moods (*left*).

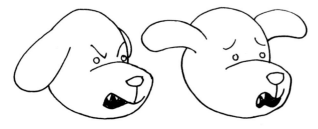

Remember that animals use their ears, teeth, and even their fur (*right*) to indicate how they are feeling.

Let's have a show of hands ...

A gesture can be worth a hundred words. Until such time as they learn to speak one another's various tongues, man and beast have only body language as a means of communication common to them both. However, the hand, or paw, can tell a story all by itself, as you can see from the images shown below.

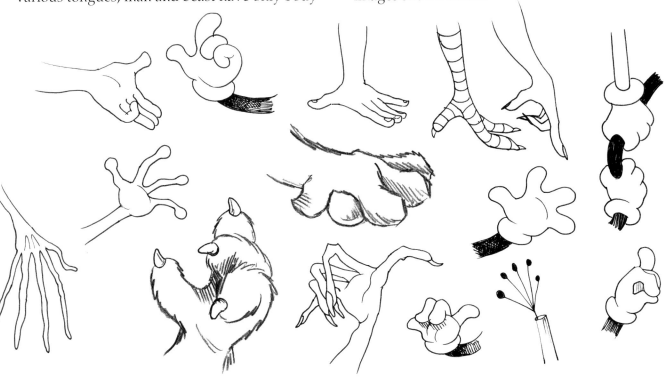

A three-fingered hand can be as expressive of mood and movement as a normal one. But there is no reason why we should not use the normal number of fingers either. Practise drawing hands as much as possible, and don't be scared of doing so.

Not only the hands but the whole body can convey a sense of character, even when static. The tense, brooding presence of this 'humanoid' demon (*below right*) contrasts sharply with the elephant's near-human expression of innocent amazement.

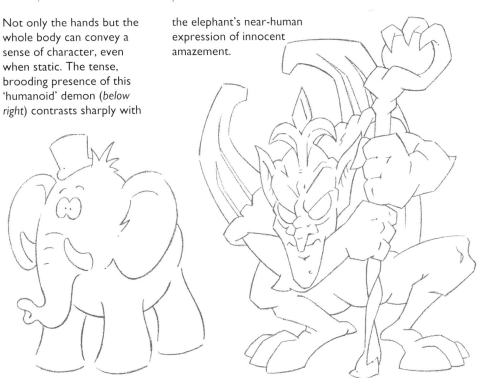

Give it a Spin

You have evolved a character. Maybe you have been drawing one favourite creature for some time. Can you move it? Or would it move better if you made a few alterations?

If you are happy with your 'hero', it's time to put together your first character-model, together with the related drawings which make up its profile. These drawings and notes will be a graphic reminder to you of all the creature's characteristics. They will be your 'character-bible'. Without such a reference, Daffy would not be Daffy, and Donald, Mickey, Popeye and Pluto would all have big personality problems!

The most important set of drawings is the one which presents the ground rules for any subsequent drawings of the character; this is known as the 'turnaround'. You may find that the trickiest drawing to do in a 'turnaround' is the profile. A lively-looking front-view can turn into something rather flat! If you find yourself with an overflowing wastepaper-bin and nowhere near a satisfactory solution, try making a plasticine model of the character.

In the system given below for creating the 'turnaround', pay special attention to the order in which the drawings are made.

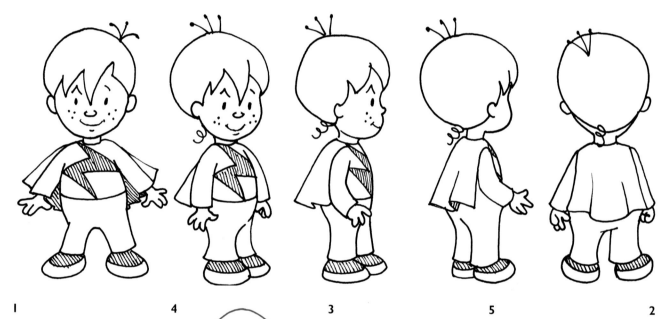

1 4 3 5 2

1 Begin by drawing a full frontal view of your character.

2 Place a fresh piece of paper over the top of this full frontal. Now imagine the rear view, and draw it.

3 If you place the front view on top of the rear view, you can think about how the character would look in profile.

The easiest way to adapt a full-face view to a profile is to think of the head as an egg-shape or ball, and slide the features sideways around it (*above*).

4 Put the front view on top of the profile and draw the position in-between the two drawings to give a three-quarter front view.

5 Then place the profile on top of the back view, and repeat the process to make a three-quarter back view of the character.

You now have five drawings of your character from different viewpoints. If you leaf through them, the character will seem to turn, and you will get your first impression of your creation 'in the round' (see the sketch of 'flipping', page 10, and the Artist's Tip on page 31). At this stage you may want to 'tweak' or amend any details which don't look quite right.

28

It is necessary to show how a character wears his or her clothes. This young heroine of an adventure series (*right*) is wearing an oversized jacket. Her designer has included information about it with the detailed instructions for drawing her.

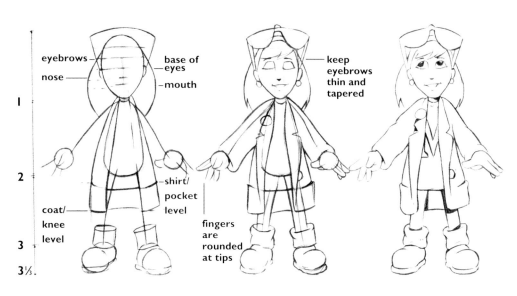

eyebrows

nose

base of eyes

mouth

keep eyebrows thin and tapered

shirt/ pocket level

coat/ knee level

fingers are rounded at tips

1

2

3

3⅓

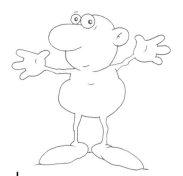

1

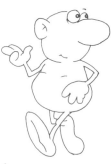

4

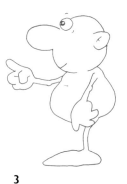

3

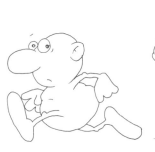

5

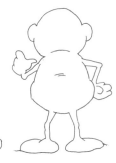

2

This series of 'turnaround' drawings (*above*) cleverly gives not only the structure of the character, but an insight into his lively personality, as well as the way he moves.

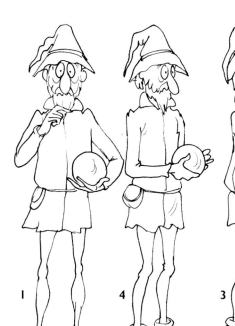

1

4

3

5

2

This is a soothsayer (*left*), shown with one of the tools of his trade, a crystal ball. We have an impression of a willowy and ineffectual individual. It is a good idea to incorporate some of your character's personality traits in the early drawings.

Key Drawings

Key drawings are the most important drawings in a sequence of animation. They are a series of poses which make up the skeleton of an action. If they do not work properly, all your effort will be wasted. These drawings must be strong and also show the direction of the movement.

When an animator has made a set of key drawings, he knows that the action will work efficiently, although he may wish to slow down or speed up parts of it to make it look more natural or, alternatively, to give it more 'punch'.

To 'smooth out' the action, and make it less violent, more drawings need to be inserted between the main key drawings. This will have the effect of slowing down the action.

In an animation studio, these 'in-betweens', as they are called, are usually made by an assistant animator, or 'in-betweener'. This work requires skill and an ability to visualize movement, and is by no means a 'mechanical' process. When an in-betweener has served his 'apprenticeship', he will be ready to graduate to the position of key animator. The best way to learn about animation is to work alongside an experienced key animator, and to watch what he does. Unfortunately, opportunities to gain experience in this way rarely arise.

1 Key animator's rough drawing.

2 Assistant animator cleans it up.

3 The revise is traced in ink on a sheet of celluloid.

4 The inked drawing is painted on the reverse side.

5 A sequence of key drawings, ready for in-betweening.

The way things were ...

Traditionally, the key animator used to make quite rough drawings which were 'cleaned up' by another artist before being in-betweened. After this, the drawings were passed on to the ink and paint department, where they were traced onto celluloid, then flipped over and painted on the reverse, using emulsion paints. Today, economics decree that an animator usually must do all his own work, including roughs, clean-ups and in-betweens. Instead of the large studios, which thirty years ago kept many people busy, there are now much smaller establishments where a handful of artists and a few computer operators turn out similar volumes of work, and few ink and paint studios exist.

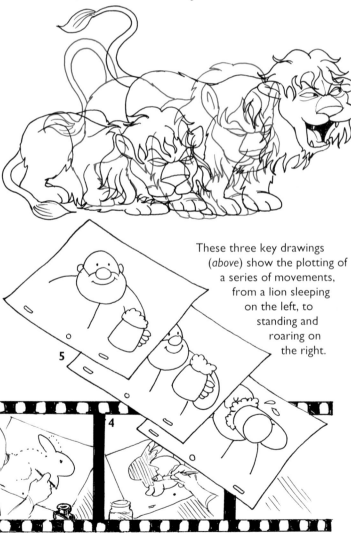

These three key drawings (*above*) show the plotting of a series of movements, from a lion sleeping on the left, to standing and roaring on the right.

Basic two-legged walk sequence

The walk is the trickiest piece of animation for a beginner to try because there are so many permutations. It is, however, one of the most important lessons to learn, and this first basic sequence will give you the pattern for all those that come after.

Your first set of keys

Put a sheet of paper on your pegs, and draw your character stepping out, with its feet at full stride (1). This is your first key drawing.

If the right foot leads the step (a), the right arm compensates for this by swinging backwards (b), and vice versa.

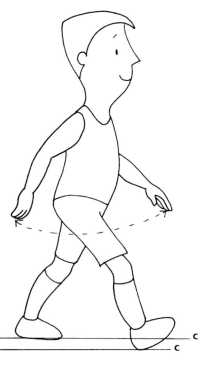

Now is the time to refer to your sketchbook, and look at those first rough sketches you made of people walking, because you are going to make your character walk 'on the spot'.

Notice that, as we have seen with the character-model, these drawings are not made in consecutive order, but there is a logic to this.

Place another sheet of paper over your first drawing, and rule a horizontal line beneath each foot (c). This gives you a walk-line guide for each foot, and should be kept beneath all the drawings as you work.

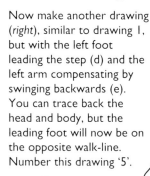

Now make another drawing (*right*), similar to drawing 1, but with the left foot leading the step (d) and the left arm compensating by swinging backwards (e). You can trace back the head and body, but the leading foot will now be on the opposite walk-line. Number this drawing '5'.

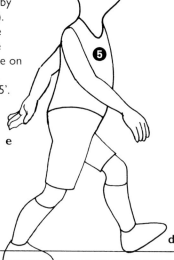

Background and 'slippage'

When a character is walking 'on the spot' a panning background (see page 11), moving in the opposite direction, runs behind it to give the illusion of movement. If the character is walking from left to right the background will have to move from right to left at the same speed. The distance the background is moved between each drawing will be the same as the 'slippage' distance. On the next two pages you will see that these 'slippage' calibrations are shown as marks on the walk-line. These help you to check the movement of the feet as you work through the sequence.

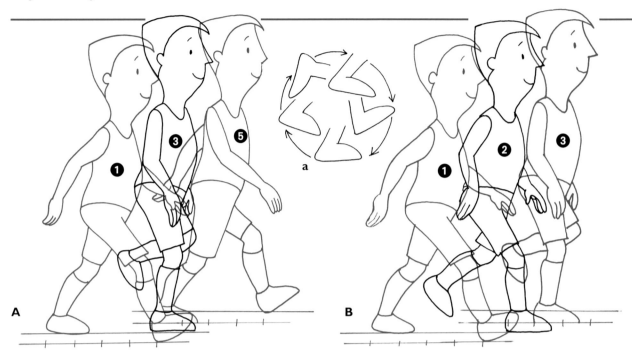

A

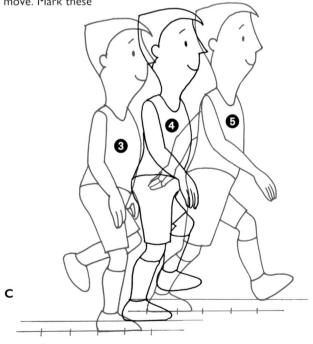

C

A Drawings 1 and 5 form the basis of the walk sequence. Before you proceed, you will need to calculate 'slippage' (see page 31). On your first drawing (1) measure the distance between the heel of the front foot and the heel of the back foot. Divide this by four and you will get the 'slippage' you have to allow for each move. Mark these calibrations on the bottom walk-line, as shown. The next drawing to make is number 3, in which the legs will be in a midway position between 1 and 5. To do this, it may help you to think of the movement of pedalling a bicycle (a), because this is roughly the action of the feet when walking. Place drawing 1 on

B

top of drawing 5, then put a fresh piece of paper on top of 1. You will be able to see the two images quite clearly, but 5 will have a greyer line. As you make the drawing (3) which goes in-between them (see page 11), remember that the back of the heel which is flat on the ground will be equidistant between drawings 1 and 5.

At this mid-step point, the load-bearing foot moves back to a position directly under the torso, slightly raising the whole body.

If you do not allow for this your character will do an eccentric 'Groucho Marx' walk. Over-exaggerating the movement will make it look equally ridiculous.

B When you are satisfied with this new in-between drawing, remove drawing 5 from the bottom level and put drawing 3 in its place, underneath drawing 1. Now draw image 2, which is the position halfway between 1 and 3. You will see that you are filling in the gaps in the movement.

C After drawing 2, tackle drawing number 4, which links 3 and 5. You have now completed half a step. At this halfway stage, it is a good idea to check that the drawings are moving smoothly. Stack them in order with drawing number 1 on the top and drawing

number 5 on the bottom and put them back on the pegs. Now slide your fingers between each drawing, as in the sketch on page 10 showing 'flipping', and gently flip the paper so that you can confirm that the action is smooth.

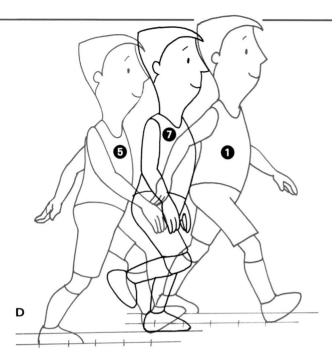

D

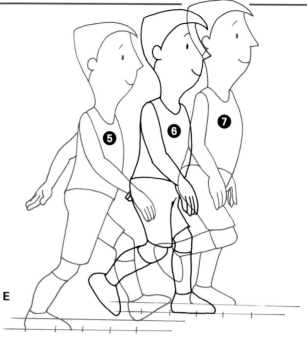

E

D Now go on to draw the other half of the step. This time you want to return your character to the position it started in, so place drawing 5 on top of drawing 1, and create drawing number 7, the pose midway between the two. Note that the body will be the same as in drawing 3, but the legs will be in reversed positions.

E Now remove drawing 1 from underneath, and place drawing 5 on top of drawing 7, in order to make drawing 6.

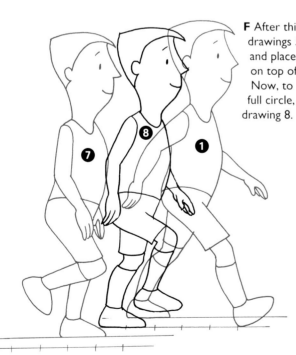

F

F After this, remove drawings 5 and 6, and place drawing 7 on top of drawing 1. Now, to bring you full circle, make drawing 8.

As you work through your sequence of drawings, make sure that the arms swing in a nice smooth arc, as their movement will help to enhance the action of the walk.

Now give yourself a pat on the back! The key drawings (*above*) form the basis of a complete 'cycle' of animation. As long as these same drawings are repeated in the correct order, your character can go on walking forever, like Felix the Cat! You can slow down the movement by inserting extra drawings between each of those in the cycle, but you now have the basic walk system.

Four-legged walk sequence

If, having accomplished the two-legged walk, you would like to walk the dog as well, the system is exactly the same, except, of course, that you are dealing with two pairs of legs instead of one. Compare the sequence of drawings shown below with those on pages 32–33. One basic point of difference – and one to note – is that diagonally opposite feet are on the ground at the same time. Zoologically, this particular dog operates like a pantomime horse,

in that its legs owe rather more to human than to canine structure, but there are four of them, and they do manage to get him from A to B! Technically, this particular walk is better suited to a bear, which, like man, is plantigrade – that is, flat-footed. If you want to draw a more realistic representation of any animal walking, you should do some picture research on the anatomy of its feet. However, the cartoon dog shown in the sequence below shares his idiosyncratic gait with many other quadrupeds, Pluto included!

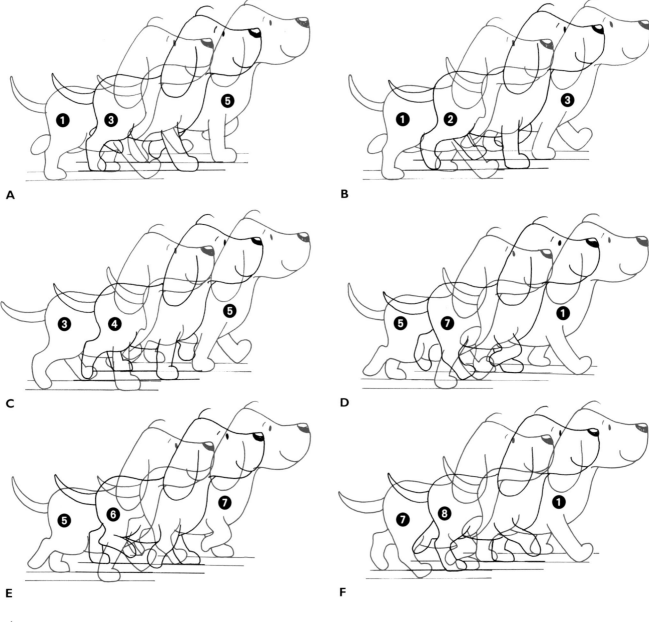

Cleaning up your character

Not every cartoon character is as easy to draw as Felix the Cat. Many characters come equipped with complicated costumes, replete with buttons, buckles and bows. All such items have to be reproduced faithfully during the animation process. Our example here is a pirate chief, who is obviously no stranger to dirty deeds. Notice that he sports not only a dashing frock-coat, frilly cravat, facial hair and spots (due, no doubt, to the poor diet onboard ship) but also a wooden leg, complete with a ball and claw foot!

An animator would need to make several rough drawings of a character like this, before producing the final cleaned-up version.

You will find it easier to use a light blue pencil when you start 'roughing out' a piece of animation, to ensure that your eye is not distracted as your drawings get messier. When you think the movement is looking right, take a sharp black pencil and start to make your final drawings.

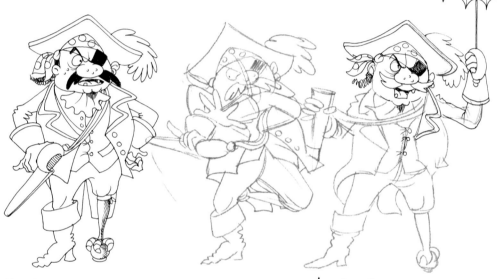

Key character drawing Roughing out (A) Partially complete rough (B)

Take the character model, and work through your drawings, remembering all the features you have to check, such as proportions, the length of limbs in relation to the body, the size of the head, ears, nose and hands. When you think you've got these elements in place, go through the drawings again, checking secondary details such as the numbers of buttons on clothing, adding or deleting them where necessary. Remember that any features which do not follow through properly will pop on and off the character as it moves, and distract the eye from all your hard work.

Final drawing (A) Final drawing (B)

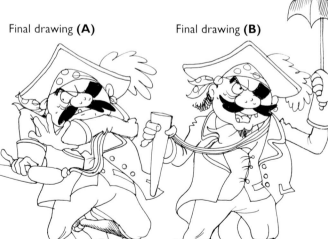

You will now have a set of lively drawings, showing the blue rough lines, and the more decisive black final drawings (*above and left*). Place a fresh piece of paper on top of each drawing, and carefully trace them all again using black pencil. Keep referring to your character model, and look out for any further mistakes. When you have finished, your drawings are ready to be shot.

Artist's Tip

All drawings which are to be coloured and shot using a computer system must be checked to ensure that the lines are clean, and that they all join up, otherwise the colours will flood from one area into another and ruin the effect.

Developing Movement

Ready, steady, go!

Everything starts somewhere, but in animation you sometimes have to go backwards before you can go forwards. Take an eager, Pluto-type hound, for instance, whose master has told him to 'stay!' He sits, quivering with anticipation, waiting for the word which will release him from his enforced stillness. His eyes follow every movement, every muscle is taut, waiting for the call, and when it comes he bounces joyfully away. In order to make the most of that happy moment, an animator would show the dog lunging backwards, and then forwards as a continuation of the same move. This ploy is known as 'anticipation', and is a very important part of the process of animation.

If you imagine yourself, like the dog, sitting, waiting for someone to call your name, you would also be tensed, ready to act. You would naturally lean backwards slightly, before transmitting the weight of your body forwards through your knees, and rising to your feet. In fact, we all do it without thinking about it.

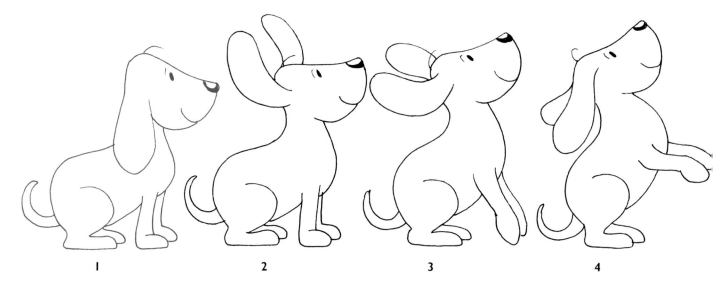

1 2 3 4

1 Seated, but alert, the dog awaits a command.

2 On hearing his master's call, he over-reacts, raising his head and flapping his ears happily.

3 Pushing off from the ground with his fore-legs, the dog rears upwards and backwards.

4 He is now sitting up, almost in a 'begging' position, but with his front paws extended ready to move forwards, his body balanced on his tail.

5 Raising his tail-end and pushing his weight off using

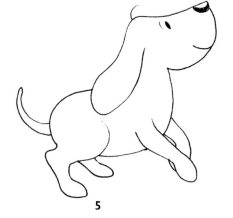

5

6

his rear legs, he bounces forwards. His nose describes an arc as he moves off.

6 His body and feet are now in the position of the first key drawing for a standard 'cartoon' four-legged walk.

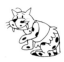

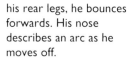

36

Sit up and take notice!

When you draw action, you soon become aware of the way other people move. Some may walk confidently, with their heads up and their chests stuck out. Others may stoop and shuffle along looking at the ground. Between these two extremes there is a wide range of other postures, which can be due to anything, from a sprained ankle to a bad temper. Watch out for them.

Another point to remember is that if animated movement is drawn to a rigid mechanical formula, it looks jerky and unnatural. Nature and movement are full of curves. Always try to move your drawing along in an arc, and don't forget to show your characters preparing to make their movements. Your motto should be 'Anticipate everything – and go with the flow!'

1 Here is a seated character, with his hands resting on his knees.

2 He responds to a summons, looking up, and raising his head.

3 He straightens his arms, and pushes his upper body backwards. His head moves further back, too.

4 Now he pushes his weight forwards onto his feet, and rises from the sitting position.

5 He shifts his weight onto one foot as he takes a step forwards.

6 This now brings him to the first key position of the two-legged walk cycle.

1

2

3

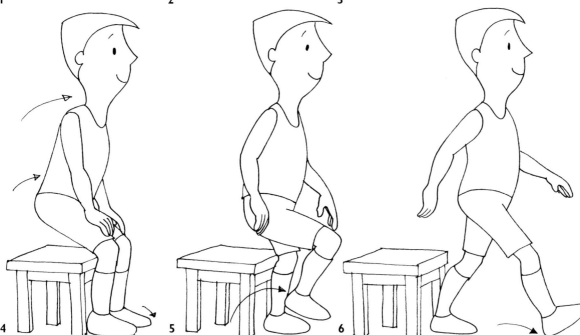

4

5

6

Running

As with the walk, the run begins with one strong drawing of your character in a full-stride running position. The body leans forwards, emphasizing speed and direction. The action of the arms is stronger, pumping the body along. The slippage of the feet is greater, too. As a general rule you might expect the slippage of the feet on a normal walk to be between 4 and 6 mm ($\frac{3}{16}$ and $\frac{1}{4}$ in). The slippage for a run would be between 15 and 18 mm ($\frac{5}{8}$ and $\frac{3}{4}$ in). On a really crazy 'motorized' run, you can thrust the body so far forwards that it is nearly horizontal, and give the legs a blurred fast-wheeling effect, but that's another lesson – the object of this exercise is to run before you gallop!

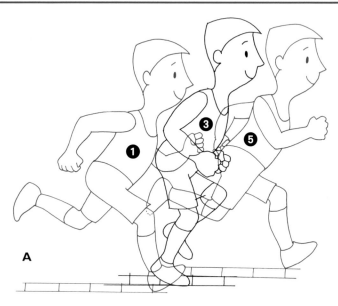

A The drawings in the run cycle are done in the same way as those in the walk cycle (page 31). First, do drawing number 1 and then draw the opposite position, and number it 5. Establish the run-line and draw position 3, which is in-between 1 and 5. Note that the circular 'cycling' movement of the legs is more exaggerated during the run, and that the feet are never flat. When they do touch the ground line, the heels are below the level of the toes.

B–C Now go on to make drawing 2, between 1 and 3, and drawing 4 between 3 and 5.

D Put 5 on top of 1, and draw 7 (the reverse of 3).

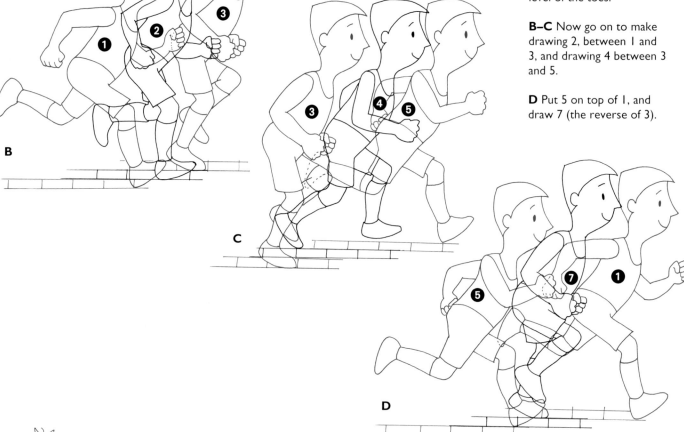

E–F Complete the procedure by in-betweening 5 and 7 to get 6, and 7 and 1 to get 8.

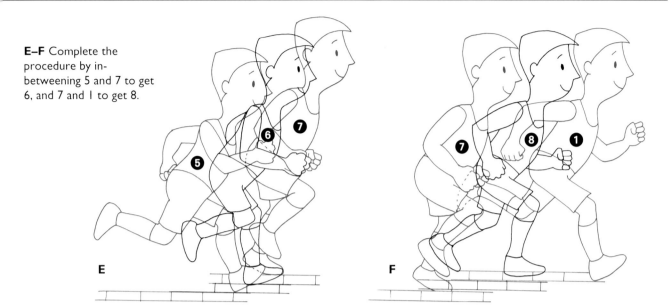

E

F

Animal run cycle

After that tour de force, you'll probably be wanting to take the dog for a run too. A dog's run is a lovely lolloping one. If you have ever watched a dog racing along, you might have wondered whether its feet touch the ground at all, and the answer is that they hardly do!

Start off with our hero at full stretch; this is drawing number 1, and one of the three main key positions in this move (A). At this point only one paw is in contact with the ground. The next drawing to do is number 3, in which all four paws are off the ground, with the two hind legs coming forwards in a leapfrog position and the two front legs going back in a circular motion. (Both front feet will hit the ground naturally in number 2, which is an in-between drawing.) The

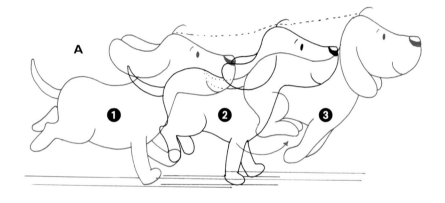

A

third key drawing is number 4, where the hind feet hit the ground, lifting the front feet and front

part of the body into the air (B). Drawing number 5 is an in-between of numbers 4 and 1. Don't

forget that if your dog has long ears, they should flap as he runs, to add to the illusion of speed.

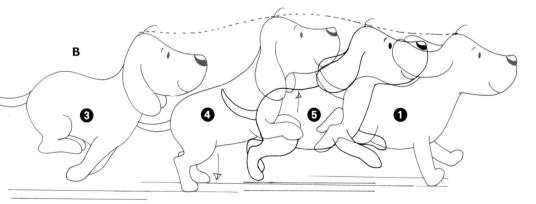

B

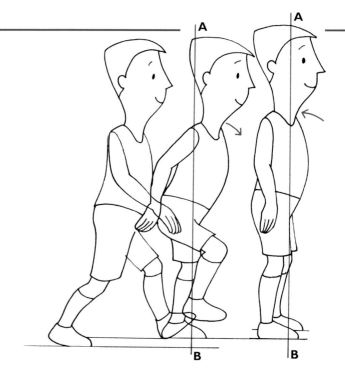

Jumping, 'taking' and stopping

The mechanics of jumping have much in common with the bouncing-ball principle which we considered earlier. The cartoon character, whether human or animal, also squashes on impact and stretches as it bounces out of the squashed position. The same sequence of movements is also used in that good old standard animation showpiece, the 'take'. This is a character's extreme reaction to an outside stimulus. As in the classic example shown below, the Roman citizen is minding his own business in a dim but relaxed fashion, when he sees or hears something shocking. He cringes into a 'squash' position, then leaps up into a 'stretch', before eventually settling back into a position close to his original one.

The great exponents of early film comedy were without doubt experts at the 'take' – just watch a few old Laurel and Hardy shorts, and you'll soon see what I mean.

You may recall that we advocated the use of 'anticipatory' drawings when starting a movement (see page 36). To show a character stopping, we use the same process only in reverse. In the drawing

above the character slightly overshoots the imaginary vertical 'finishing post' (A to B) as he comes to a halt and then settles into his final upright position, thus emphasizing the action.

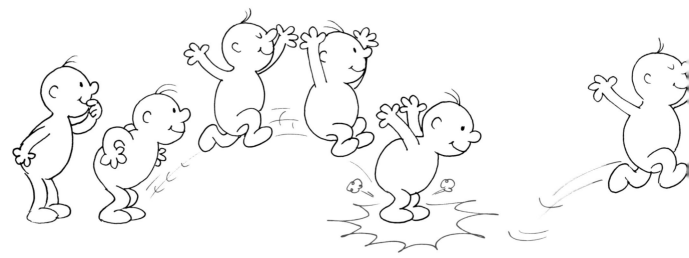

Some of the more dramatic methods of effecting a stop come into force when an animated object, travelling at speed, comes abruptly into contact with a static one (*above and above right*).

Fortunately, both elements usually survive! In the 'stopping' sequence shown above, note that the victim registers impending disaster just before he hits the tree, when the crunch is

unavoidable. It would be nice to make his movement slow down slightly at this point in order to emphasize the drama. A little bit of desperate backwards 'pedalling' works wonders

in such a situation! And after having one's progress so rudely interrupted, it only remains to 'do a wind-up' and zoom off in search of another mishap (*far right*).

40

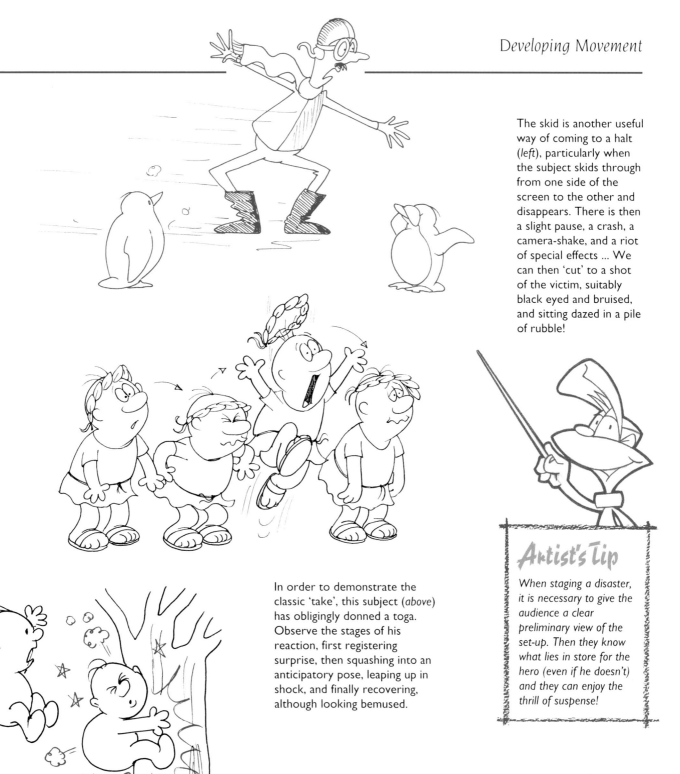

The skid is another useful way of coming to a halt (*left*), particularly when the subject skids through from one side of the screen to the other and disappears. There is then a slight pause, a crash, a camera-shake, and a riot of special effects ... We can then 'cut' to a shot of the victim, suitably black eyed and bruised, and sitting dazed in a pile of rubble!

Artist's Tip

When staging a disaster, it is necessary to give the audience a clear preliminary view of the set-up. Then they know what lies in store for the hero (even if he doesn't) and they can enjoy the thrill of suspense!

In order to demonstrate the classic 'take', this subject (*above*) has obligingly donned a toga. Observe the stages of his reaction, first registering surprise, then squashing into an anticipatory pose, leaping up in shock, and finally recovering, although looking bemused.

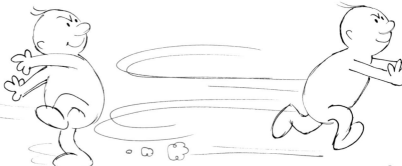

Flying

If you are a born flyer, as opposed to someone with a ticket to fly, the way you move depends on weight and shape. When a sequence of animation is filmed, each drawing is usually exposed for two frames, but an action like flying which is slow, graceful and balletic, can be shot on three-frame exposures, or even more. These slower movements are generally exhibited by larger birds, such as swans; the smaller the bird, the swifter the movements. Birds with a wide wingspan tend to soar up into the wide blue yonder with scarcely a flap.

In the world of flying things we must not forget insects either – the flutter of a butterfly and the dizzy dance of the bee mirror the flight of smaller birds, and the swoop of the dragonfly is similar to that of the eagle. The longer the wingspan, the more regal the flight should be.

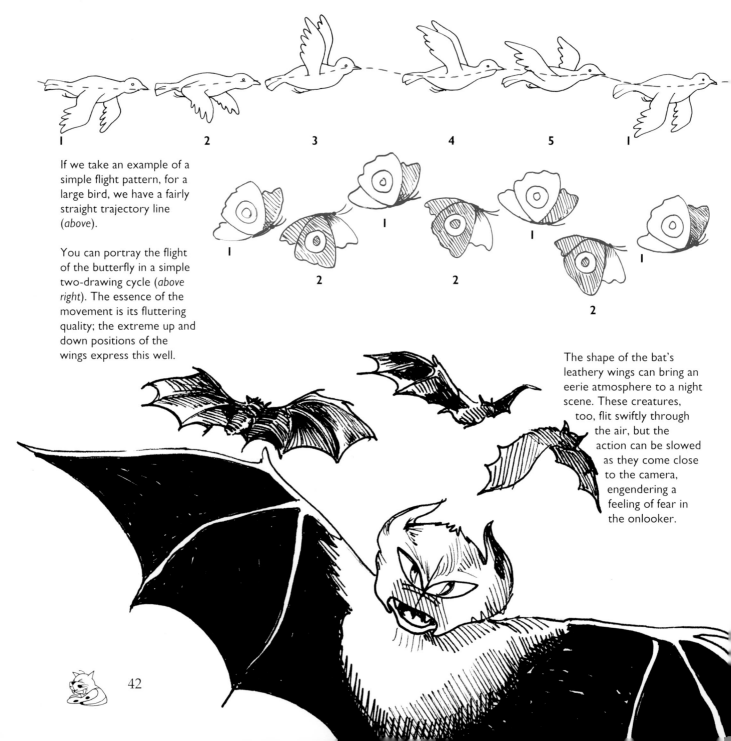

If we take an example of a simple flight pattern, for a large bird, we have a fairly straight trajectory line (*above*).

You can portray the flight of the butterfly in a simple two-drawing cycle (*above right*). The essence of the movement is its fluttering quality; the extreme up and down positions of the wings express this well.

The shape of the bat's leathery wings can bring an eerie atmosphere to a night scene. These creatures, too, flit swiftly through the air, but the action can be slowed as they come close to the camera, engendering a feeling of fear in the onlooker.

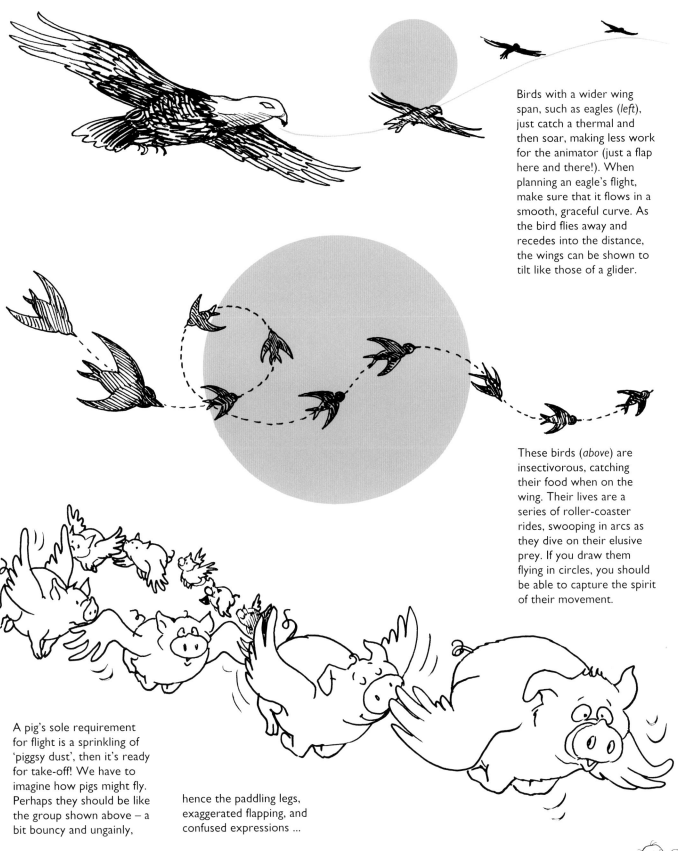

Birds with a wider wing span, such as eagles (*left*), just catch a thermal and then soar, making less work for the animator (just a flap here and there!). When planning an eagle's flight, make sure that it flows in a smooth, graceful curve. As the bird flies away and recedes into the distance, the wings can be shown to tilt like those of a glider.

These birds (*above*) are insectivorous, catching their food when on the wing. Their lives are a series of roller-coaster rides, swooping in arcs as they dive on their elusive prey. If you draw them flying in circles, you should be able to capture the spirit of their movement.

A pig's sole requirement for flight is a sprinkling of 'piggsy dust', then it's ready for take-off! We have to imagine how pigs might fly. Perhaps they should be like the group shown above – a bit bouncy and ungainly,

hence the paddling legs, exaggerated flapping, and confused expressions ...

43

Morphing

This is about the most fun you can have in animation. Morphing is the process of changing one character into another by a succession of drawings. The permutations are limitless, although often a gradual change in size or shape is funnier than a sudden one. A good example to experiment with here would be the slow evolvement of a frog into a prince. Why not try it yourself? However, a 'pantomime' transformation such as this is usually over in a flash. Much more delightfully gruesome would be to show it happening slowly ...

Whichever character you start with, think about how one particular feature can be stretched to lead into the next form you have in mind. If you start with a two-legged character, it may be that the body will tilt forward, and the arms become forelimbs as it changes into a four-legged animal. If that four-legged animal becomes a bird, the hind legs might fold up to become wings. There are no rules for morphing, but there is a crazy kind of logic that demands a smooth transition from one state to the next, and you have to ensure that you provide just that.

Here is an example of a simply doodled morphing sequence. It continues across the opposite page, and then from left to right along the bottom line. We start with a basic small humanoid figure, who drops forwards onto his fore-limbs and becomes a quadruped ...

... The penguin doesn't remain a penguin for long. It elongates its neck and goes through a vaguely dinosaurish phase before becoming a kangaroo. How will it end? ...

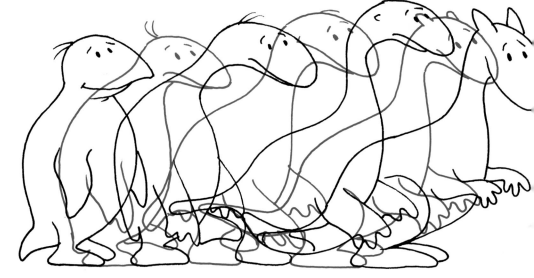

A nodding acquaintance with anatomy is invaluable for the animator who likes morphing. If you begin to think of the muscles which control form and movement as a system of ropes and pulleys operating the frame of the skeleton, it will give you ideas about how to proceed

when changing the shape of your 'morphee'. Morphing is also an amusing way to practise the art of in-betweening, and you can surprise yourself if you start this particular form of animated doodling, as you never know where it might lead in terms of creating ideas.

... The newly transformed 'horse' now grows a hump and becomes a camel. The camel's hind legs fold neatly

up to become a pair of wings, and the fore-legs move further back along the body as a flamingo

evolves. This in turn shrinks its legs and lowers its undercarriage to become a penguin, which continues

the morphing process in the sequence at the base of the opposite page ...

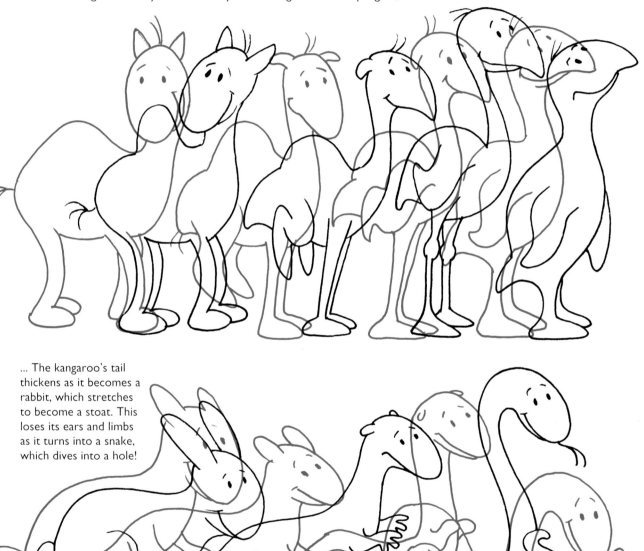

... The kangaroo's tail thickens as it becomes a rabbit, which stretches to become a stoat. This loses its ears and limbs as it turns into a snake, which dives into a hole!

Special Effects

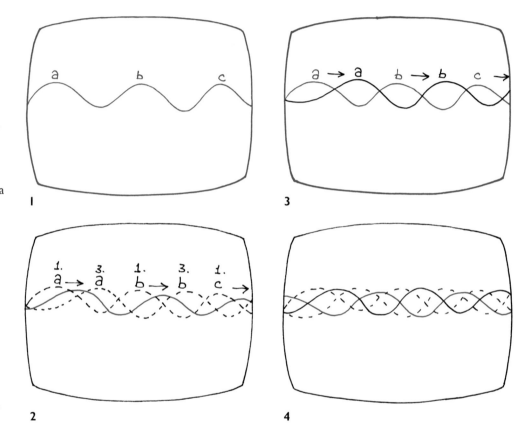

The undulating wave-like movement of a snake is mirrored in the movement of water. When we animate wave effects using either regular or irregular wave patterns, we create a repeating cycle of peaks and troughs which can move to left or right. As before when we created the walk cycle (see pages 31–34) the order in which the drawings are made is not consecutive. This method of working using one basic key drawing is known as a 'one back to one' cycle and is very common when drawing other special effects such as those shown here.

1–4 Drawing 1 is a line of waves each of an even size and shape. We want to make them move sideways across the screen from left to right so that peak (a) moves along to take the place of peak (b) and so on.

Put a fresh piece of paper on top of drawing 1, and make a drawing which shows the peaks moved to a halfway point, between (a) and (b). This will be your next key drawing; call it 3.

Then place 1 on top of 3, and in-between it to create drawing 2.

Place 3 on top of 1, and in-between it to create 4.

You now have a repeating cycle of waves. If they are filmed in forward sequence (1, 2, 3, 4 repeatedly) they will move from left to right, and if shot in reverse (4, 3, 2, 1 repeatedly) from right to left.

A–B For choppier seas you need a sequence in which the waves not only move from left to right, but also increase and decrease in size as they do so. In these two illustrations (*right*) A corresponds to drawing 1 above, and B to drawing 2.

Use the same principle if you want to produce animated drawings of a flag fluttering in the breeze (*far right*).

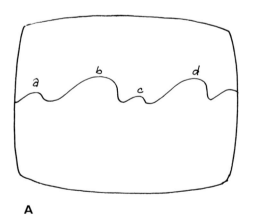

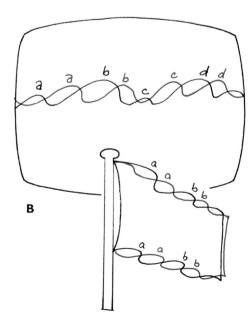

If you want a ripple effect (*right*), begin by making a drawing of the complete ripple area then place a fresh piece of paper on top of this. Starting with the centre circle and moving each circle halfway out towards the next one, draw the next key drawing. The outer ripples can break up into dotted lines and vanish

A

B

as they reach the outer edge of the area (A). The innermost circle can form again to fill the space left at the centre as the ripples

move out (B). Call this drawing number 3, then in-between 1 and 3 to get 2 and in-between 3 and 1 to get 4. For a more realistic

effect do extra in-betweens to slow the action. The impression should be of a constant movement outwards from the centre.

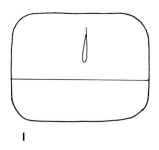

1

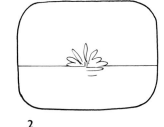

2

3

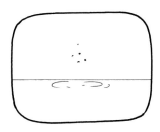

4

There are two distinct causes of a splash. The first (*shown above*) is a drop of water falling into a pool. This is an easy animation effect to achieve.

As the drop hits the water (1) a 'splash back' is formed (2) which dissipates in a few smaller splashes and bubbles as the drop is absorbed into the pond or puddle (3 and 4).

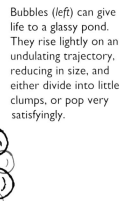

Bubbles (*left*) can give life to a glassy pond. They rise lightly on an undulating trajectory, reducing in size, and either divide into little clumps, or pop very satisfyingly.

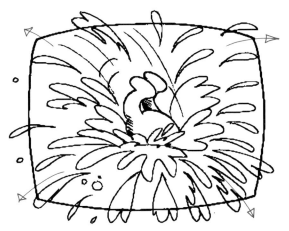

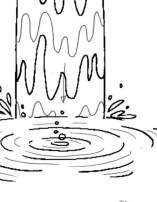

The second kind of splash (*above*) occurs when a sizeable body hits water, causing it to fly upwards. Every drop of displaced water, large and small, has to be followed through to its logical conclusion,

whether it flies up out of sight, or splashes back into the main body of the puddle. Drawing a splash sequence of this type can be labour intensive, so they are usually planned to be of very short duration.

The waterfall effect (*right*) combines elements of both wave and ripple animation. This time the water animates vertically downwards and 'disappears' into a rippling pool, which throws up bubbles. The cycle illustrated looks quite lively and impressive, but was achieved in only four drawings, after a bit of crafty planning.

Rain

When animating rain and snow we have to think about weight again. Rain is heavier than snow, and falls faster. The trajectories of rain and snow are also different. For the purposes of animation we usually portray rain falling as shown below. Snow follows a more eccentric pattern.

Rain rarely falls straight down from above, and usually follows a slanting course. If you are drawing a screenful of the stuff, you need to plot that course with some care. A convincing rainstorm can usually be produced in a cycle of three drawings, so it is well worth the effort of additional preparation.

A

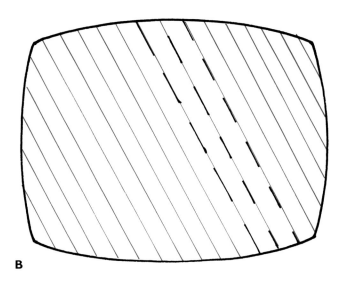

B

A Using a light blue pencil, begin by ruling a screenful of guidelines for your rain.

B Now take a black pencil and draw lines representing the rain, each of a similar length and evenly spaced. You can simply rule a sequence of straight lines, but you will make the effect more realistic if you emphasize the weight of water at the base of each droplet by thickening each line at its lower end.

This diagram (*right*) shows the movement of raindrop (a) down its guideline to raindrop (b). Your second drawing should be positioned about a third of the way between the two extremes, and the third drawing is halfway between 2 and the last drawing. The dotted line on the far right shows the position of the raindrop above.

If you are drawing a whole screenful of rain, prepare your guidelines as shown in A above, then draw the lines representing the rain

(B). Place a fresh piece of paper on top of this, and make your second key drawing, moving each shaft of rain down the line, about a third of the way towards the one below it. Now place drawing 2 on top of drawing 1, and complete the cycle by making drawing 3, which is an in-between of them. Start at the top of the paper and work downwards, along each line of raindrops, otherwise you might find your shower of rain making a fateful directional change! (See Artist's Tip opposite.)

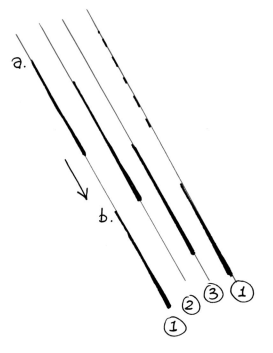

Snow

The animation of snow needs careful plotting. Snowflakes drift down through the sky on an undulating path, rather like the feather we considered earlier. We need many more drawings to achieve a realistic effect of each flake floating languidly down to earth. Try to allow for six in a cycle. For a good screenful, draw two different snow cycles, and shoot them together. Make one cycle of small flakes, well spaced out, and another of larger ones, set closer together. In order not to swamp the action or the background with the prevailing weather conditions, rain and snow effects are usually double-exposed; that is to say, they are shot twice, in order to give a transparent appearance.

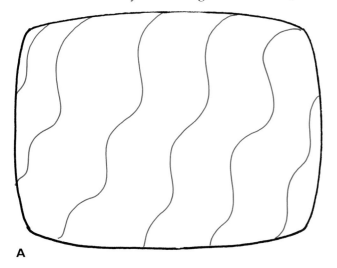

A

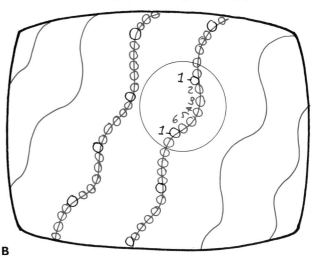

B

A Begin by plotting the trajectory of each flake; this time the screen will be filled with wavy lines.

B Draw the snowflakes meandering along each line, allowing enough room between each flake for five more flakes, all fairly closely spaced.

When drawing snowflakes, follow each flake consecutively through its fall (see circled area, *above*). Start by placing a piece of paper on top of drawing 1, and, working down the line, produce drawing 4. Put drawing 1 on top of drawing 4, and, placing a fresh piece of paper on top of that, make drawing 2, one third of the way between 1 and 4. Then put drawing 2 on top of drawing 4 and produce 3, halfway between them. Now put drawing 4 on top of drawing 1, make drawing 5 two-thirds of the way between them, then put 5 on top of 1 and in-between them to make drawing 6. You have now joined up the chain of snowflakes and arrived back at 1. Repeat the process for every snowflake in your blizzard and you should end up with a snow scene like this (*left*).

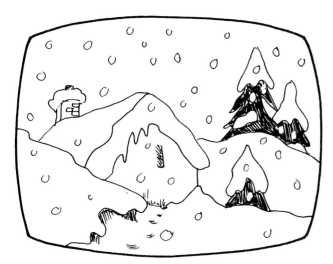

Artist's Tip

When drawing rain or snow, it is important to in-between all your drawings in the same direction. There is nothing more aggravating than watching an impressive-looking downpour of animated rain, only to notice that one of the drops is working its way merrily UP the screen.

A puff of smoke

There is no smoke without fire. Let's now consider puffs and plumes!

Here is a familiar scenario: out in the desert we hear the muffled beating of war drums; the Apaches are 'phoning home' – see below.

That distant column of puffs could be used equally well for smoke from a chimney stack or a steam engine. In the case of the latter, the smoke should stream out horizontally behind the engine, unless it is just an old 'puffer' chugging along. The method of producing it remains the same.

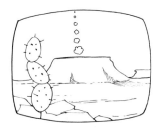
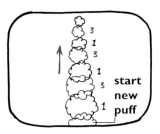
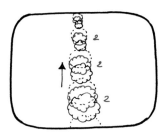
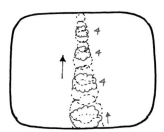

Drawing a cycle of smoke puffs has much in common with drawing rising bubbles. As they rise the puffs reduce in size and vanish (see Artist's Tip opposite). This is another 'one back to one' operation. Notice the order of drawing.

First of all, draw your rising column of smoke-puffs, then put a clean piece of paper on top of that drawing, and make the second drawing, moving each puff upwards to a position halfway between the puffs marked 1. Call this drawing 3.

Now place drawing 1 on top of drawing 3, and on a new sheet of paper in-between each puff on drawing 1 to the one above it on drawing 3. Call this drawing 2.

Then place drawing 3 on top of drawing 1, and on a new sheet of paper in-between each puff on drawing 3 to the one above it on drawing 1. Call this drawing 4.

A plume of smoke

You might see the type of plume of smoke shown below rising from the chimney of a quaint 'Hansel and Gretel-type' cottage, nestling in the middle of an enchanted forest. It could

equally well be seen coming out of a kettle-spout, or drifting lazily up from the crater of a dormant volcano (see opposite). The kind of smoke cycle used in these scenarios works on the 'wave' principle (see page 46).

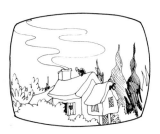
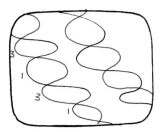
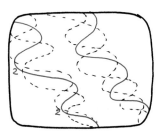
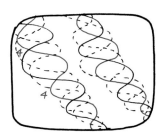

Here is a nice rural retreat, with a wisp of smoke curling lazily from its chimney. If you replaced the cottage with Aladdin's wonderful lamp, the smoke cycle would still look appropriate.

Make drawing 1, then place a sheet of paper on top of it and make the second drawing, moving curve 1 halfway up towards the next curve 1, and call it drawing 3.

To complete the cycle, place drawing 1 on top of drawing 3, and on a new sheet of paper in-between each curve on drawing 1 to the one on drawing 3. Call this drawing 2.

Then place drawing 3 on top of drawing 1, and on a new sheet of paper in-between each curve on drawing 3 to the one above it on drawing 1. Call this drawing 4. Remember that the direction is upwards.

Fire

If your sleepy old volcano should decide to erupt, you are faced with the problem of drawing fire. Like rain and snow, fire requires a distinct track to follow, and then it will behave beautifully. Vary the organic, tongue-like shapes of the flames as they leap upwards, and follow the same procedure as you did when drawing the plume of smoke. As in the case of rain and snow, drawing fire requires some concentration, as the sequence needs to be followed through carefully in order to look effective. Flames are also double-exposed when shot, to give a realistic transparent effect.

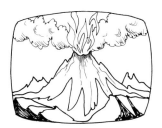 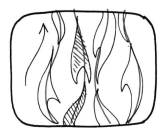 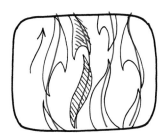 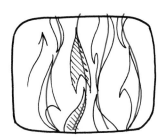

Here is our erupting volcano, complete with billowing clouds of ash, flowing lava, and leaping flames. To see a stunning animated volcanic sequence, look at the 'Rite of Spring' section of Disney Studios' *Fantasia*.

These organic shapes are used to represent flames. Their colours vary; usually a combination of red, orange and yellow. Also in imitation of the changing nature of fire, the larger flames can split and separate as they pursue one another upwards.

If you are trying to follow a set of flames as it curves upwards through the screen, it is often helpful to shade in one line of the shapes in order to avoid confusion and having flames jumping across from one column to another.

Unlike rain or snow, which are 'all over' effects, fire tends to be confined to one area. Before you start, think about the shape of that whole area, and plan your fire-cycle so that you can make the flames dance up convincingly.

Combining puffs and plumes

The plume of smoke issuing from the spout of the kettle shown below, and puffs escaping as the lid bangs up and down, tells us that the kettle is boiling.

Clouds, and clouds of smoke, or dust, which hover in the same area for a time, behave in the same way and may billow on the spot. To achieve this effect draw your cloud, nicely curvaceous in outline, and, as with the wave cycle (see page 46), move each curve on towards the next one, clockwise around the body of the cloud. Make this into a cycle of four drawings, or in-between each of these drawings in turn to make a cycle of eight or sixteen, thus slowing the movement to a slow 'boiling' motion.

Artist's Tip

You may be concerned about what happens at the 'top end' of a smoke sequence, and wonder how to finish off the effect. In a column of smoke puffs, each one diminishes in size as it rises higher, and at its highest point it bursts rather like a bubble, into a cloud of tiny puffs which spread out and 'evaporate'. This can be done in the space of about three drawings.

Props

In this great big technological world of ours, we are very proud of our 'props' – the flashy car, the washing-machine, the power-shower, the big lawn-mower; the list is endless. Of course, things can – and do – go wrong with domestic machinery, but not half as wrong as they can go in 'Toon' world!

It is not impossible, and far from unusual, for a 'prop' to evolve into a character all by itself. You find yourself drawing some eyes on a watering-can, for example, and before you realize what is happening, a new and rare species of elephant is born! Even a gentle pastime like gardening becomes perilous when we meet the carnivorous lawn-mower, the garden hose that turns into a giant anaconda, rockery stones that rise up on little legs and walk away, and a host of other things too horrible to mention.

This may look like a complicated way to make a cup of tea, but the gentle bubbling is better than a screeching kettle when you've got a sore head.

Necessity is the mother of invention. As man developed bigger and better weapons, he had to work out some way of getting them to the field of conflict easily and without using up too much energy.

From the primitive technology of the caveman, and the invention of the wheel, to the sophisticated laboratory equipment of the mad scientist, cartoon man has always required his props – and not just cartoon man, either. Where would Wile E. Coyote be without the ingenious contraptions of the Acme Company?

You will see from the few examples shown here that a nodding acquaintance with special effects can come in very useful when dealing with animating props!

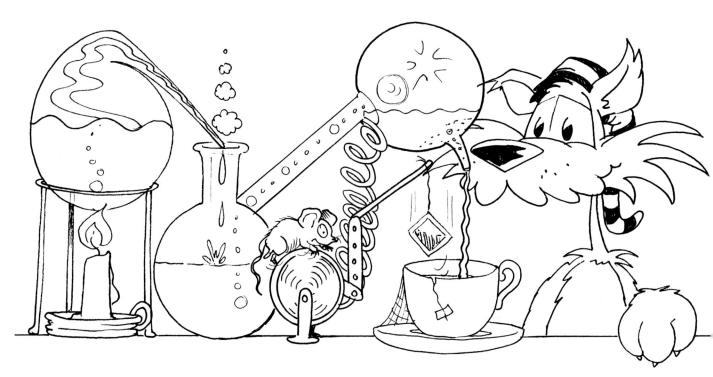

It is a short step from giving a mouse human attributes, to doing the same for a lawn-mower. When one of these machines gets bored with its vegetarian diet, and starts baying for human blood, the only thing to do is to cut and run!

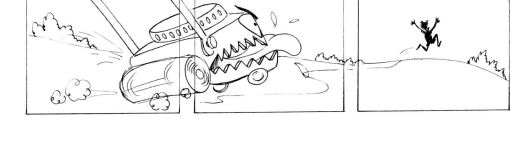

Here we see an old 'bone-shaker' throwing itself into lively locomotion. Notice that the body of the car stretches and squashes as it bounces along. This is quite a restrained vehicle – if there were any deeper ruts in the road it would be flying.

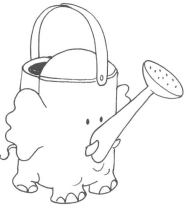

A simple wheelspin, as shown in the lower sequence above, consists of three drawings. Divide the wheel into six segments, and draw 'speed' lines in two opposite segments (1). Then work your way around the wheel, moving on to the next two opposite segments (2). When you have completed the third pair of segments (3) you will be back at 1.

Here is another example of how a prop can take on a life of its own (*above*). When the spout became an elephant's trunk, this watering-can also sprouted a set of stumpy legs, and is now contemplating a safari down the garden path.

Some 'props' even make it big and aspire to have their own starring roles in books and TV series, like Dennis the Digger here (*right*) – something a humble egg-cup may only dream about!

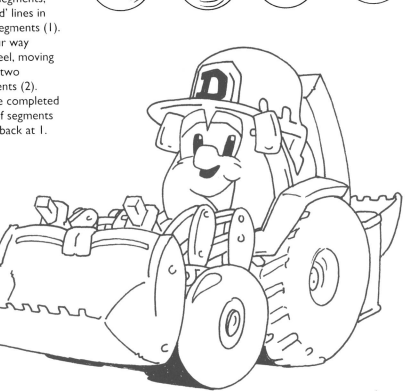

Choosing a World

You have invented your cast of characters. They can use the wheel and sail their boats on stormy seas, but what about the world they inhabit?

When you choose your world, you set a style. It could be as simple as a limbo of flat walls and doors, which your hero can fold up and walk away with, or as complex as a gothic castle, cobwebby and full of eerie shadows. Your world could be set beneath the sea, on a distant planet, in the present, past or future, or, like Alice's, through the looking glass. The most important thing is that your characters are at home in this place.

Some characters dwell in a world which is no more than a ground-line, while others might inhabit a collection of dustbins, but in every case their surroundings 'fit' them. 'Tom and Jerry' stories unfold against a backdrop of skirting-boards and chair-legs. We hardly ever see more

than two or three feet above ground level, but we associate what is there with the two characters. If we were to walk into that house, we would know who lived there.

When work begins on a cartoon series, the direction team maps the area where the various characters live, and plots the interior of their homes. This plan becomes as important to the storyboard, layout and background artists as a character-model is to the animator.

Where characters run through doors and jump out of windows, backgrounds are often split into several sections, known as underlays or overlays, to accommodate the action. Windows and doors which animate are drawn on separate levels and carefully matched to the rest. Many of the greatest pieces of artwork in animation have been the work of the background department.

'Mr Midnight's' study (designed by Graham Garside) is very different in style from the backgrounds shown opposite.

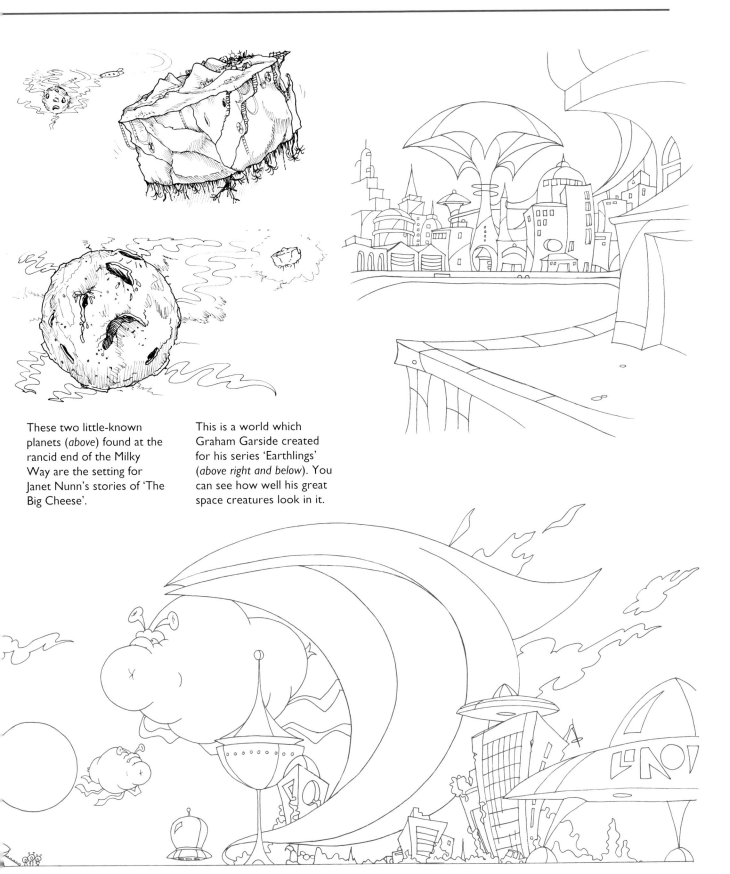

These two little-known planets (*above*) found at the rancid end of the Milky Way are the setting for Janet Nunn's stories of 'The Big Cheese'.

This is a world which Graham Garside created for his series 'Earthlings' (*above right and below*). You can see how well his great space creatures look in it.

A Cunning Plot

What are you trying to say?

Now that you have assimilated some of the basic techniques of animation, you will want to have fun with them and put them to good use. It is quite possible for you to use the techniques outlined here to produce a two- or three-minute film, without recourse to complicated procedures. So consider what you want to do. Whatever you decide to tackle, careful planning of your work is essential.

If you're going for entertainment, do you have a plot? If so, can it be told simply and effectively? How many characters do you want to use? And most importantly, how long have you got? But cartoons have other uses besides entertainment. They can also be used to educate, to sell, and to promote propaganda. So consider your message, jot it down and start plotting the next move.

A question of timing

A cartoon film runs at a speed of twenty-five frames per second. This means that a minute of film contains fifteen hundred frames. It does not mean that you have to make fifteen hundred drawings, however, because each drawing is usually shot for two frames. Nor do you even have to make seven hundred and fifty, because the timing of the action often requires drawings to be 'held' for much longer, and even repetitive movements can be effective at a slower rate.

Staggered movements

One of the most complex aspects of the animator's art is timing. It is important to be aware of the fact that in normal movement not all parts of the body are in operation or move at the same time. You have to ensure that your drawings reflect this reality.

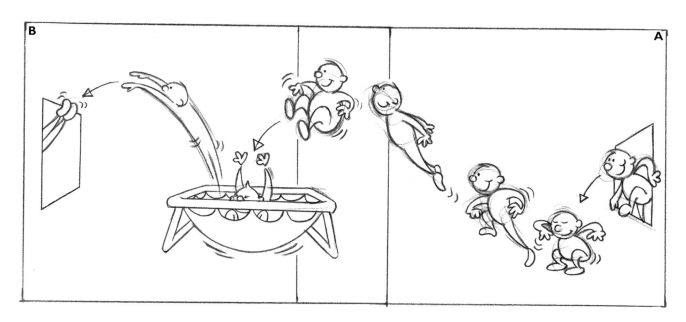

A layout for a complicated piece of animation is a kind of plot. If an acrobat were to attempt this move (*above*), he would need some rehearsal. Similarly a layout artist 'rehearses' the move for the animator, and assesses how much space will be needed.

This is a long running shot, in which the character moves swiftly through screen A on the right, and then the camera pans across with him in order to see him jump onto the trampoline and then bounce out of the window in screen B on the left.

Plotting the action is a way of planning the background. Now that we know where the windows should be in relation to the trampoline, it is easier to fit the rest of the background around them. The artist can fill the details appropriate for the style of the film.

The animator then thinks about the pace of the action. He may decide to hold the character after it jumps into the room, to give it time to look around before it spots the trampoline, or make the dive into the trampoline more acrobatic.

Splitting the levels. . .

The drawings of animated characters are split into different sections, known as 'levels', and layered in order on top of the background. By dividing a figure so that the head, arms and legs, eyes and mouth can move at varying times while the body remains in a held position, the drawing workload can be much reduced, but for this intricate system to work efficiently, careful note has to be made of every tiny move, on charts known as 'dope-sheets' (see Jargon Buster, page 10), which give the camera/computer operator clear instructions on how the film should be shot.

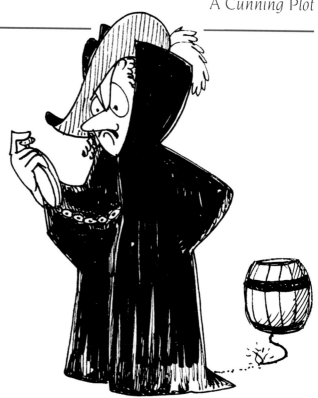

Here is a timely reminder that not every scheme works out according to plan, however well laid ... The tension builds as that tiny flame inches closer to the barrel of gunpowder, and tension should always be part of the animator's armoury.

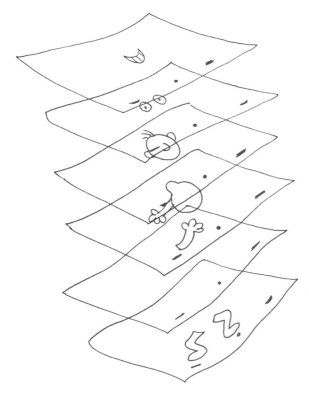

The stack of drawings above shows how an animator might divide a character into several different body parts, each of which can move and be re-used independently. Although this scheme saves a lot of extra work, it demands careful organization. Each drawing has to be numbered and noted so that it can take its place in the correct order when being shot. If a character is split in this way, while the body and one arm remain static (third sheet from bottom of the pile), the mouth can chat, the eyes can blink, the head turn from side to side, one arm can wave and the legs can dance a jig!

As clients do not like to be kept waiting for their TV commercials, it is often necessary for the professional animator to burn the midnight oil. At such times it is important to evict the cat, remember where you put your coffee cup, and stay calm.

Creating a Storyboard

The storyboard is the plot of a film shown in comic-strip form. Each frame represents a piece of action, and no production begins before the storyboard has been thoroughly worked out.

The master plan

The storyboard is the film's master plan. It is used by the layout artist as a guide for his drawings, which set each scene, giving a plan of action to the animator, as well as a set design to the background artist. The storyboard is occasionally filmed itself, as a series of static shots, each of which corresponds in length to the scene it portrays. Whenever a piece of animation is completed, the moving scene is substituted for the still one, so that the director can monitor the progress of the whole film. In the hands of the storyboard artist the script first springs to visual life, setting the style and pace of the production.

Getting started

Storyboard pads are obtainable from good media and artists' suppliers. They come in a variety of designs, but all provide spaces below each frame, to enable you to give a description of the action and to write out the dialogue. You can also make up your own, simply by drawing a pageful of frames.

Making a scene

You will find that your plot divides naturally into scenes. Some scenes will be more complex than others, and will need several frames of board to describe them, but one frame will be sufficient for most. Sometimes the action may be repeated, and a scene can be re-used. Remember, in animation a 'scene' might last just a few seconds, and be only a few feet long. As to the plot, keep it simple, but try to give it a twist.

A Simple Storyboard

Frame 1 A country scene: the sun is shining, a pond ripples in the foreground, birds fly across from west to east ...

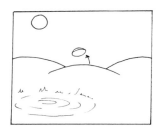

Frame 2 Repeat of frame 1, but up from behind the distant horizon whizzes an alien spacecraft.

Frame 3 The UFO comes right up to the front of the screen ...

Frame 4 ... which goes dark as the alien ship fills it. End of Scene 1.

Frame 5 Cut to a similar landscape as before. The spaceship has landed.

Frame 6 The same landscape ... the top of the ship opens like a lid, and a space creature climbs out.

Frame 7 The creature walks up to the front of the screen and stops. As it does so the lid of the spacecraft closes.

Frame 8 The creature looks to the left of the screen, then to the right ...

Frame 9 ... and walks out to the right. Cut. End of Scene 2.

Frame 10 On a background representing the sky, a looking-up shot, as the creature moves up and across the screen.

Frame 11 The creature's body fills and darkens the screen, causing a blackout (known as a 'wipe'). End of Scene 3.

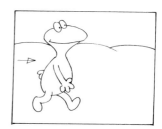

Frame 12 Similar background to that of Scene 2. The creature enters and walks across screen from left to right. Cut. End of Scene 4.

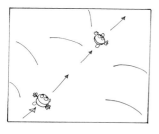

Frame 13 This is a crafty bird's-eye view of the alien walking diagonally across the screen, over a hillocky background. Cut. End of Scene 5.

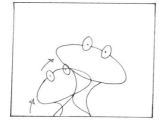

Frame 14 Much of the animation from Scene 3 is re-used here. Against a sky background, the alien creature comes into screen, and stops.

Frame 15 It raises its hand to its mouth, puzzled, and blinks. Cut. End of Scene 6.

Frame 16 A rear view of the creature; it has stopped in front of a cliff, at the entrance to a cave.

Frame 17 As it stands looking on, a huge eyelid slowly opens in the 'cave'. The creature reacts in horror. End of Scene 7.

Frame 18 Cut to a close-up shot of the creature's 'take' (see page 40.) End of Scene 8.

Frame 19 A long shot, looking up, which reveals that the creature is actually standing on the beak of a monstrous bird-like beast of prey ... End of Scene 9.

Frame 20 Whatever happens next? Over to you! There is scope for anything here: horror, comedy, a good old-fashioned chase sequence, a sneeze, a belch, a scratch ...

The Big Bang

A trip down memory lane

The history of animation probably began when one of our distant ancestors sat down in a smoky cave and drew a herd of oxen galloping across the walls and ceiling. In those days it was magic.

Later, the Egyptians, Mayas, Aztecs, Incas and all the rest made drawings on the walls of their temples and tombs, of people hunting and dancing, animals running and birds in flight. This too was magic.

If a daring time-traveller whizzed back to those distant times to screen a 'Loony Toon' for the assembled company, who knows what fun and games might have ensued?

As for further flights of the imagination, such as inventing plots and gags for cartoon films, a cynic might say that much of it has been done before. True, some of the most hair-raising situations were dreamed up as live-action stunts by such geniuses as Mack Sennet and Buster Keaton, but when the first animated film-stars appeared, they took up the batons passed on by the Keystone Cops and ran with them.

Who could ever match the ingenuity of Wile E. Coyote in his quest for the elusive Roadrunner? And was not Goofy's teetering on the tower in *The Clock Cleaners* even more alarming than any of Harold Lloyd's escapades?

Animation's appeal is that it combines humour with magic. How else could a mouse smack a cat with a frying-pan, or a bear walk off a cliff into thin air, and keep on walking? Despite the attempts of academics to wipe the smile off its face, the cartoon film keeps bouncing back. The popularity of shows such as *The Simpsons* and *South Park* tells us that it has a future as well as a history. Let's all look forward to it.

We thought it would be better to end with a bang, so here is a short sequence for you to consider.

Frame 1 The hero, who is not over-bright, is walking along whistling and thinking of nothing in particular ...

Frame 2 ... when he comes across a bomb, helpfully labelled 'BOMB', lying in his path.

Frame 3 Instead of running for cover and calling the emergency services, the dolt picks it up, turns it over, and notices the smoking fuse.

Frame 4 He looks at the camera in amazement and ... there's a BIG BANG!

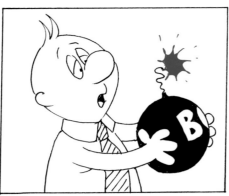

1

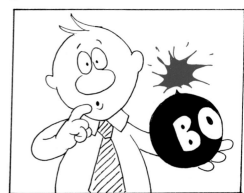

2

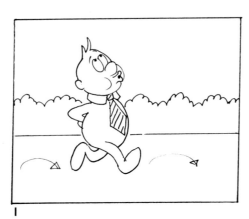

3

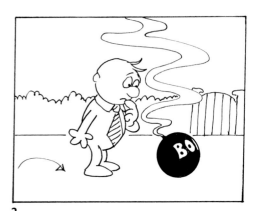

4

Frame 5 The screen fills with a brilliant multi-coloured starburst effect, centred on the point where the 'bomb' exploded. This moves outwards very fast, to the screen edges and off. As it does so the central star regenerates from the middle, and the whole effect keeps going for as long as you want it to.

Frame 6 Then a small puff of smoke appears at the centre of the flashing starburst.

Frame 7 This swiftly grows to fill the screen, covering the other effect.

Frame 8 As it grows, the centre of the cloud opens out as a clear space, through which the charred and battered hero is finally revealed.

5

6

7

8

Frame 8 alternative
Fortunately, our hero usually gets away with little more than severe singeing of the whiskers. If he should be blown to smithereens, the smithereens invariably reassemble themselves. On the rare occasions when a big bang proves fatal, however, he ends up on a fluffy cloud, wearing a clean white nightie and playing a harp. So, we have a satisfying choice of scenarios.

Artist's Tip

Over the page you will find out how you can make your own animated films, using either a camcorder or a PC. If you become a proficient animator, and find that you enjoy using some of the techniques we have shown you here, you might like to consider looking for an Internet website where you could show your film to a worldwide audience.

Using a Camcorder and PC

Technology is advancing at such a pace that there are frequent updates and improvements to software and hardware products coming onto the market. Here we will concentrate on giving you a basic outline of the processes involved in getting your animation on to video and/or through your PC, and wait, with you, to see where the technology takes us next.

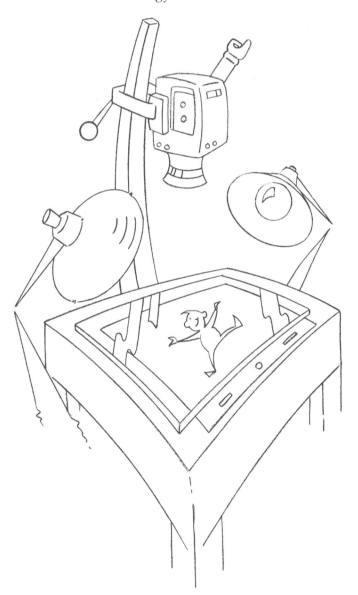

This drawing shows you how to set up your camcorder to shoot animation. The sheet of glass on top of the drawing keeps it flat, avoiding distortion. Great care must be taken not to nudge the peg-bar or camera when changing one drawing for another.

The camcorder

You will need a camcorder with a single frame facility, clamped firmly to a rigid support, a couple of adjustable lamps, and a rigid, sturdy table top, to which you can tape your peg-bar. You will also need a clean sheet of glass, slightly larger than your drawing.

Every drawing must be placed on the peg-bar, and held flat by the glass as it is filmed. This ensures the accuracy of 'registration'(see Jargon Buster, page 11). The slightest movement of the table, the camera or the peg-bar between shooting each drawing will result in your animation jumping around on screen in a way you hadn't anticipated.

You need the lights to help give a clear and true representation of your work. If at all possible, use white 1000 kW bulbs. Position them equidistant from the centre of the table top and about 45 cm (18 in) above it, pointing downwards, to give an even, flat spread of light across your drawing.

Before you start, write down how many frames you are going to shoot for each drawing, and where you want extra ones ('holds'). Then stack your drawings in the correct order. Now click your cassette into the camcorder, and shoot!

Do not unload the camera or attempt to review your animation by removing the camera from its support, until you have completed shooting an entire sequence, or you will disturb the registration of the set-up. (See second paragraph, above.) When you have finished, watch the results on your TV.

The PC

You can use your PC as an animation line-test machine (checking the drawings to make sure they move correctly) and shoot the finished film on it too. For this you will need the equipment set up as before, with the exception of the camcorder. Instead of a camcorder, the PC method uses a basic digital camera which is

linked to the computer, and enables you to grab each drawing as digital information, which is then relayed to the monitor screen.

As an alternative to the digital camera, you could use a scanner. Professional studios use multi-feed scanners which work very quickly, and can accommodate the many thousands of drawings required on series and feature work. The personal scanner works more slowly, and the sharpness of the image may vary. Because you cannot get a peg-bar into a scanner, there may be problems in maintaining perfect registration. However, by making your own registration marks on the scanner glass, or butting your drawings against a hard edge, you should be able to overcome this difficulty.

A small digital camera, similar to those used for shop-surveillance, and fitted with the correct connectors for your PC, will do the job nicely. You will need relevant animation-specific software, which is not cheap, but is readily available. This will enable the computer to grab the images, via the camera, one drawing at a time, to store them in order, and to display an on-screen 'dope-sheet' (see Jargon Buster, page 10). This will allow you to insert, swap, or delete drawings, if you want to correct or improve the animation. The camera and PC combined will display the drawing you are about to shoot as a 'live image' on screen, so that you can focus and reposition it for a new scene, or check the contrast. When your sequence has been shot, instruct the PC to replay the animation, and watch in wonder, before storing your work on a floppy disc. You can now transfer your film to a VHS video format.

To transfer your animation from the PC to your video-player, you will need a Genlock, a device which, when connected from the PC to the video, converts the information to a video signal.

To avoid making expensive mistakes when buying specialized computer equipment, always consult your dealer, who will advise you on software, hardware, cameras, leads, and the compatability of the elements you will need to run your system.

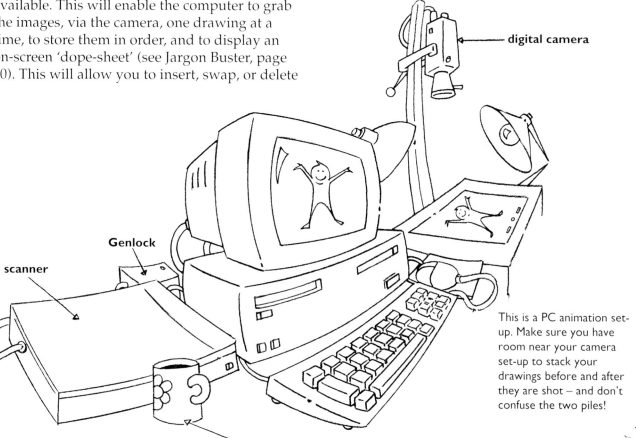

digital camera

Genlock

scanner

This is a PC animation set-up. Make sure you have room near your camera set-up to stack your drawings before and after they are shot – and don't confuse the two piles!

mug of tea or coffee